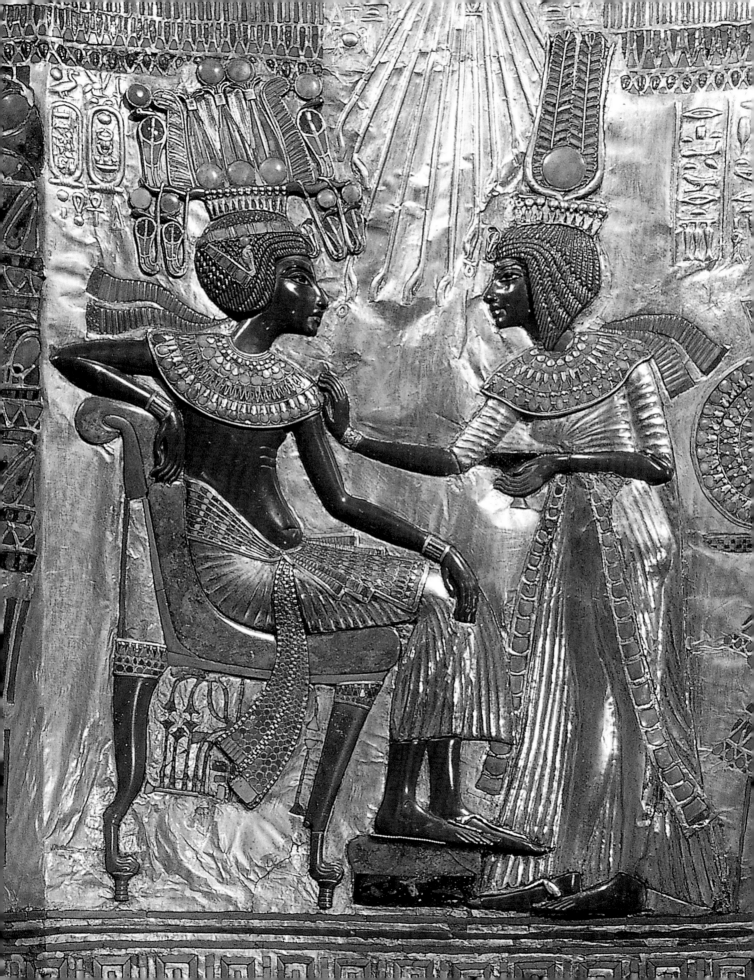

Rose-Marie & Rainer Hagen
Norbert Wolf (Ed.)

Egyptian Art

TASCHEN

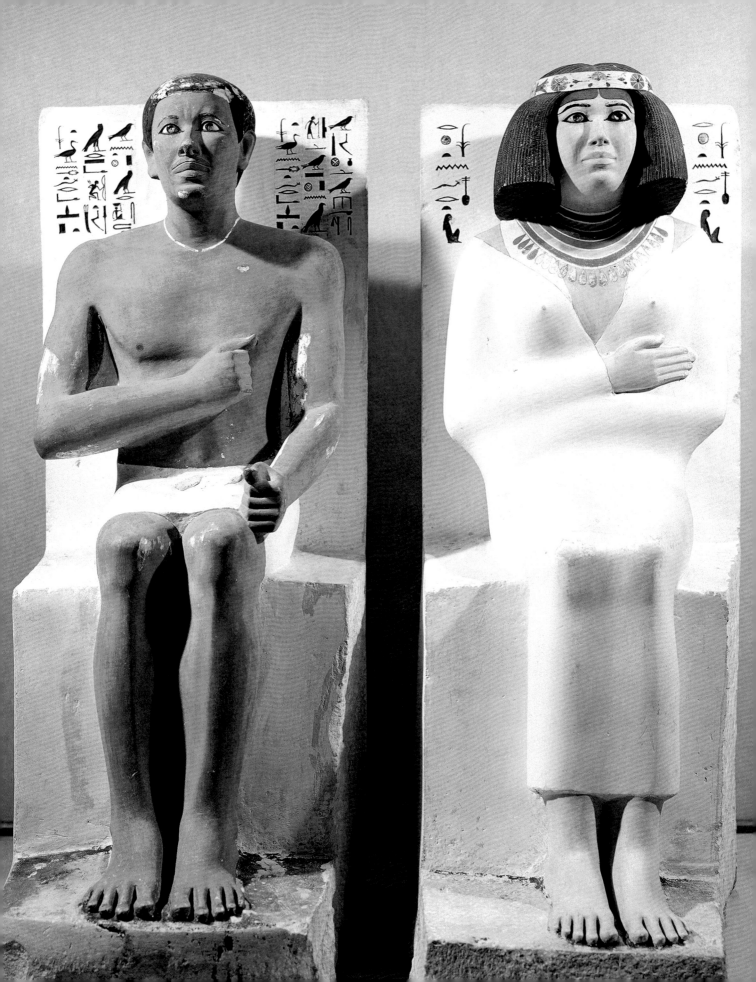

Contents

6 **The Imagery of the Pharaohs' Kingdom**

28 **Old Kingdom, 3rd dynasty —**
King Djoser

30 Hesy-Ra at the Dining Table

32 **Old Kingdom, 4th dynasty —**
The Geese of Meidum

34 **Old Kingdom, 5th dynasty —**
The Seated Scribe

36 Anonymous Couple

38 Return of the Herd

40 The Pyramid Texts of King Unas

42 **Middle Kingdom, 11th dynasty —**
Grave Relief of Ashayt

44 **Middle Kingdom, 12th dynasty —**
Sphinx of Senusret III

46 **Second Intermediate Period, 13th dynasty —**
Ka Statue of Pharaoh Auibre Hor

48 **New Kingdom, 18th dynasty —** Relief from
the Sarcophagus of Queen Hatshepsut

50 Senemut and Neferure

52 Pharaoh Thutmose III Slays the Enemies

54 Servants at a Banquet

56 Three Girl Musicians

58 Seated Figure of the Goddess Sekhmet

60 Queen Tiye

62 Hunting Scene in Papyrus Thickets

64 Husband and Wife at a Banquet

66 Female Mourners

68 Head of Amenhotep IV (Akhenaten)

70 Royal Family

72 Queen Nefertiti

74 Gold Mask of Tutankhamun

76 Necklace of Tutankhamun

78 **New Kingdom, 19th dynasty —** Dancing Girl

80 Anubis Watches over the Mummy

82 The Judgement of the Dead

84 Reedbeds

86 **Third Intermediate Period, 22nd dynasty —**
The Eye of Horus

88 **Ptolemaic Period —** The Horus Falcon
in the Temple of Edfu

90 Two Goddesses Crowning the Pharaoh

92 **Roman Period —** Mummy Portrait
of a Woman

95 **Chronology of Ancient Egypt**
(after Beckerath)

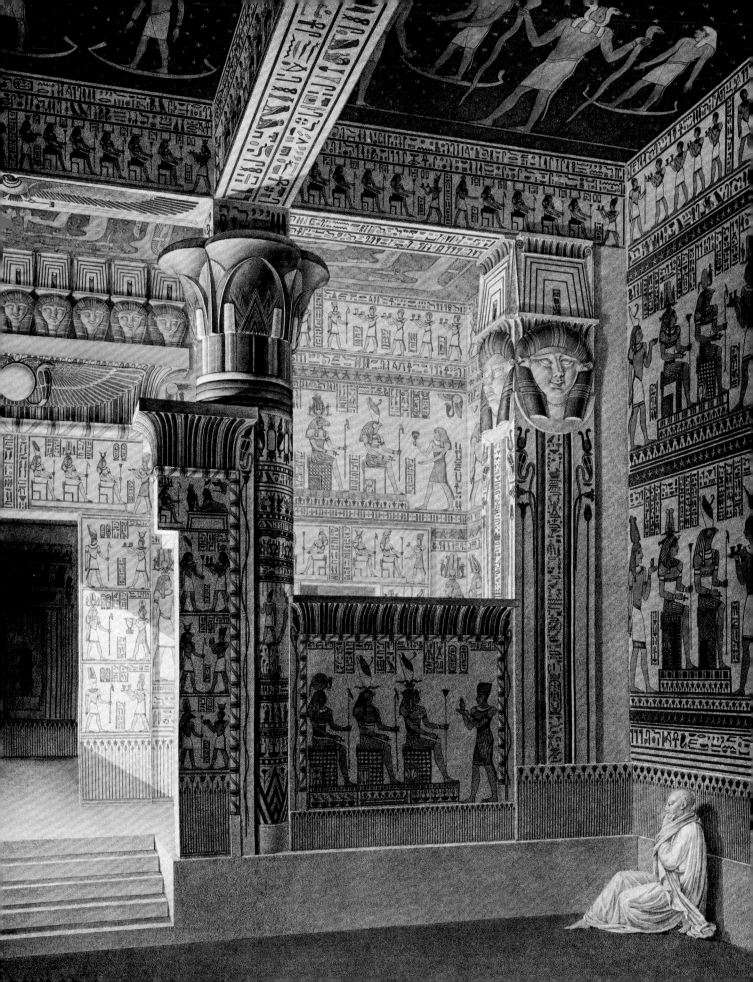

The Imagery of the Pharaohs' Kingdom

Whenever anyone thinks of Egypt the first thing they almost automatically think of is the pyramids. They stand for an entire country and a great, ancient culture. They have been, and still are, copied. The entrance building to the Louvre in Paris is just one example. When the political climate permits, tourists flood to Giza to marvel at the formidable, mathematically tamed mountains of stone. Then they have to ask themselves how humans could have built them. The highest, the Great Pyramid of Giza, also known as the Pyramid of Cheops or Khufu, was 146 metres tall when it still had its tip. The Greeks counted the Great Pyramid of Giza amongst the Seven Wonders of the World, while Napoleon called out to his soldiers: "Forty centuries look down upon you!" By now it is forty-two.

The Great Sphinx of Giza, the king's head on a lion's body, is also located at the pyramid complex. The stone used was quarried locally. It is 20 metres high and more than 73 metres long (ill. p. 9). No tourist misses the opportunity to look into its broken countenance. In Greece the male sphinx became a female one who would give travellers riddles to solve. Those who failed were eaten. This lasted until Oedipus came. He knew the correct answer. Beaten, the sphinx threw herself off her rock and died. The Greek sphinx is a daemon, whereas the Egyptian sphinx is a ruler and a guard, the animal body symbolizing super-human power. The Egyptians invented this half-human, half-animal creature. From Giza it then made its way into European imagery. The sphinx has remained alive to this day as decoration in front of houses and palaces, or as a spooky character in horror films and novels.

A further large structure originating in Egypt is the obelisk; in contrast to a pyramid an obelisk is not put together from individual stones, it is a monolith made of rose granite and may be up to 32 metres tall. The reason we name numbers when talking about a pyramid, a sphinx, or an obelisk is because the enormous format was part of the concept. The works were intended to impress. They served "higher" purposes. Obelisks were erected so that the sun god could settle there during his daily journey across the sky. The shaft tapering towards the top had a gold-plated tip that reflected the sun's rays. Often an altar was located at its base. The Romans brought a large number of obelisks back to Italy. Rome alone is said to have had 40 obelisks at one point (ill. p. 7). Later they became a popular form of monument in Europe, although usually in a smaller format adapted to the human scale.

Readers may ask themselves why we decided to start a book on Egyptian art with three large structures that do not quite fit into our concept of art, of visual art. But why do they not fit? Because they are too big? Too architectural? In any case they are works of brilliant simplicity. We could even speak of archetypes. Their strength has made

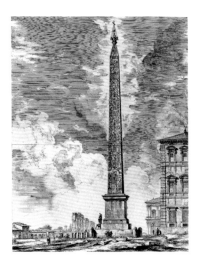

Giovanni Battista Piranesi
**The Lateran Obelisk in the Piazza
di San Giovanni in Laterano**
(detail), 1759
Copperplate engraving,
53.5 x 40 cm (21 x 15¾ in.)

**View into the Temple of Hathor
in Deir el-Medina**
Aquatint, in: *Description de l'Égypte*,
vol. II, plate 37, Paris, 1812

A view into the west temple of Deir el-Medina in Thebes. Only a few traces of paint remain on the walls and pillars. 19th-century artists attempted to reproduce the temple's original state in their pictures. The name Deir el-Medina means "monastery of the town"; the building dates from the Christian era.

them exert their fascination on us through the ages. They have however lost something on their journey through Western history, something crucial: their religious origin. A museum entrance, a terrace decoration, a monument for the remembrance of a human being – these are all profane works. They were originally created as religious symbols, as an object of worship or with an eye on the afterlife. They were sacred monuments. What is true of the three most popular creations is also true of all paintings, reliefs, and statues as far as they have survived. Egyptian art was sacred art.

The Afterlife in this Life

The pyramids were protective buildings – oversized safes. They were meant to prevent robbers from penetrating to the royal mummy, disrupting its peace, and stealing gold and gemstones. For that reason the passages inside the pyramids were blocked and the entrance disguised. Of course the height of the monuments was also meant to make the pre-eminent significance of the dead kings clear. Their significance was not however based on any political or social merit, it came from the status, from the office – at first the Egyptian kings were considered to be divine, and later to be the sons of the supreme god. The pyramids were also meant to make their journey to heaven easier. "The gods lift you up on their arms," says one of the pyramid texts, "and you ascend, our king, up to heaven and climb up to them as if on a ladder," says another. The later rock tombs also served to preserve the mummies. The Egyptians believed in a life after death and hoped for immortality within their earthly bodies. Initially this was only true of kings and their relatives. For this reason only they were mummified. Later this belief spread to other groups in society. The procedure took 70 days. Accompanied by magical utterances, the internal organs were removed, while the rest of the body was washed, dried, and swathed. Kings like Tutankhamun received gold masks that priests placed on their faces, while private individuals used masks made of stuccoed, gilded canvas. As part of the sacrificial cult, statues were placed in the burial chambers. If need be, these statues could serve as substitute bodies into which the soul could return if the mummy were destroyed.

Before the deceased was allowed to enter the underworld his heart was placed on a pair of scales and weighed against a feather, which was a symbol of Ma'at, the goddess of justice. If the heart was heavier than the feather it was devoured by Ammit, the "great devourer of the dead", who was depicted as a monster that was part crocodile, part wild cat, and part hippopotamus. This was the worst of all conceivable punishments: it meant final death. However, the Egyptians took precautionary measures. They had a kind of guide through the underworld, an adviser who knew all the right utterances and answers. The utterances from the Old Kingdom chiselled into the royal pyramids have come down to us. We also have utterances from later periods that were written on sarcophagi and papyrus scrolls. These were statements such as: "I have not done any injustice to another human being, nor mistreated an animal… I have not held back the flood waters." This did not have to correspond to the truth, but was meant to act like a magic formula to keep the scales in balance. Those who passed the test were reunited with their bodies and returned to their graves where they were cared for by relatives or priests. At the same time the deceased tarried in heaven or a kind of paradise and was allowed to accompany the sun on its journey – he attained a highly desirable existence, close to the gods and free from all the earthly constraints.

The desire to live forever in the beyond dominated the thinking of ancient Egyptians, and not just shortly before their death. The pharaohs began building their tombs as soon as they came to the throne. Higher officials also started early, as can be seen by the artistic decor of the chambers carved into the rock. The wall images of the pharaohs only praised the gods, the beings from their own divine sphere. The tomb images of the others celebrated the world they had left behind. They depicted vine-covered arbours, musicians, revelry, wife and children, the joys of hunting birds in the thicket of papyrus grasses. They also showed the deceased's property, his herds and fields and his richly

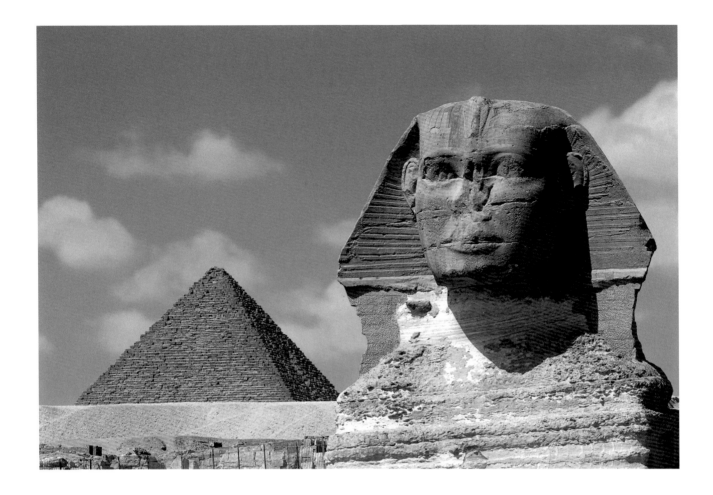

laid table. It was the best sides of life the deceased wanted to remember and it was these he hoped to experience in the afterlife. The tomb images display a sugar-coated panorama of Egyptian life, but despite these euphemistic representations they form a unique document of life on the Nile.

The afterlife and this life were closely intertwined. This can be seen both in the death cult and the temple customs. The son brings his dead father food and says: "My father, stand up! Receive this water! … Raise your face so that you see what I do for you. I am your son!" The son feeds the father in the afterlife, the gods enter this life and live in temples. There they had their earthly homes. All over the country pharaohs erected magnificent, fortified houses for them. Every new pharaoh had to build new ones or at least expand existing temples by building porches and annexes. Every day the statue in which a god had settled was decorated, made up, and supplied with food by priests. For special festivals the priests placed the statue in a litter-like processional barque that belonged to the god, carried it to the Nile on their shoulders, placed it on a floating barque, and rowed the statue to a fixed destination – usually to a temple of a related cult.

The mass of people were never allowed to see the cult images in the processional barques' closed cabins, but in their imagination the gods and goddesses lived right amongst them. They did not just travel high up in their heavenly barques across the horizon or at night time on the Nun, the river of the underworld, to ascend again in the morning. They also lived on Earth, settled on the peaks of obelisks, and lived in their temple houses. The proximity between humans and gods, between this world and the next, affected their art and led to an individual style, a canon that held good from the Old Kingdom to the Late Period.

Pyramid of Cheops with the Great Sphinx of Giza, Old Kingdom, 4th dynasty
Giza

"*I was mourning on my throne, those of the palace were in grief… because Hapy had failed to come in time. In a period of seven years, grain was scant, kernels were dried up… Every man robbed his twin… Children cried… The hearts of the old were needy… Temples were shut, Shrines covered with dust, everyone was in distress…*"
— INSCRIPTION ON THE "FAMINE STELE" FROM THE CATARACT ISLAND OF SEHEL NEAR ASWAN, PTOLEMAIC PERIOD

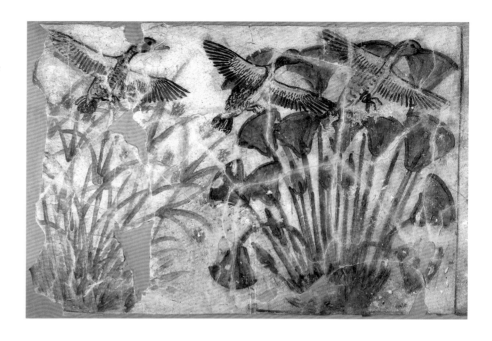

Fragment of a Painted Palace Floor from Tell el-Amarna,
New Kingdom, c. 1350 BCE
Plaster, painted, height 100 cm (39¼ in.),
width 150 cm (59 in.)
Berlin, Ägyptisches Museum

"The Ethiopians (= Egyptians) do not use any letters, but only different animals, their limbs and organs. Earlier priests only taught their own children this allegorical or symbolic way of writing with characters in an attempt to keep their knowledge about their own spiritual teaching a secret; a woman beating a drum means 'joy', a man grabbing his chin, looking down means 'sorrow', a tear-filled eye 'misfortune.'"

— CHAIREMON OF ALEXANDRIA,
1ST CENTURY CE

Art and its Canon

Egyptian art was a sacred art – as far as it is known to us. Only a portion of it has survived. Pictures and ornaments on the walls, ceilings, or on the floors of houses and palaces have all been lost apart from a few exceptions (ill. p. 10). The walls of the houses were made of bricks, which were formed from Nile mud and dried in the air. Rarely have they survived across the millennia. The surviving remains make it likely that the canon of the sacred art was also used on the walls of profane buildings.

Strict rules that had not however been formulated in writing were particularly applied to frescoes and reliefs. One of them stated that in light of the gods and eternity the human form was not worthy of being captured. Whether on the pharaohs' temple walls or in the officials' grave decorations – the heads and bodies were always stylized to a norm. Signs of illness remained invisible. This was usually true of signs of age as well. An inscription clarified who was meant. In two-dimensional art the human body was reduced to a slender, well-built, young adult, because a person's individual appearance, his flesh, was coincidental and the current condition was transient.

Personality traits were not standardized to an ideal to the same extent in all periods, but the tendency to do this remained for more than 3,000 years. The combination of two different perspectives also remained during the entire time. Beholders see the person depicted, be it a man or a woman, partly in profile and partly frontally. The head and body are shown from the side, while one eye and the shoulder area are shown from the front. No explanation for this change in perspective has survived, but it can be assumed that the Egyptians wanted to show what was important to them as directly as possible. We are not so surprised by this as the art-lovers of the 19th century were – painters like Picasso have conditioned us.

Proportions were also part of the canon of rules. They did not correspond to reality, but to social rank. The pharaoh was larger than his official, and the official was larger than his servant or even than his wife. If idealization, dual perspective, and sizing by importance are all taken together, then it becomes clear that the figures were "conceived" rather than "seen" – instead of a photographic reality they created a mental representation. The art and skill of the Egyptians was to make these constructs look like normal living beings.

Also typical of two-dimensional Egyptian art is the absence of a simulated third dimension. There is no spatial depth or distance. If an animal was meant to be closer to or

further from a beholder, the artists represented the animals in the background as being covered by the animals in the foreground – not completely, just as much as necessary. We know that the Egyptians were able to grasp area and space very precisely in their practical thinking. Every time the Nile flooded they had to measure all the parcels of land anew; funerary images show men with measuring tapes, pacing out a field. However, away from practical life, when it came to thoughts of religion, earthly three-dimensionality, human space, collapsed in upon itself. It was, by the way, also absent in mediaeval European art. The Christian saints stand or die on a thin strip of earth in the front of the picture, while a gilt background unfolds behind them – a symbolic heaven. After the Greeks, the fact that the third dimension could be represented on a two-dimensional surface was rediscovered by Renaissance painters.

Nor could an image construction using correct perspective have been reconciled with the so important "sizing by importance". The two representational principles would have cancelled each other out, for in true perspective, it is not importance, but distance from the beholder, that determines apparent size. A surprising solution was

Pond in a Garden, New Kingdom, before 1350 BCE
Wall painting in Nebamun's tomb, tempera on stucco, height 64 cm (25¼ in.)
London, The British Museum

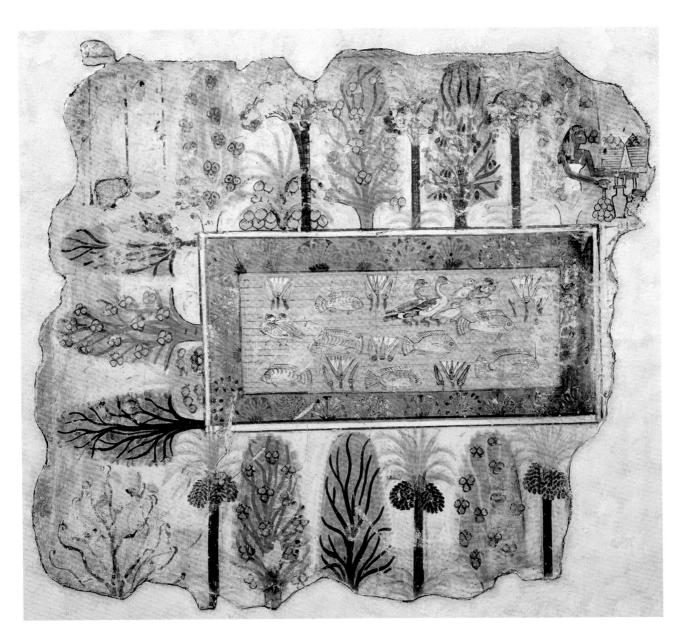

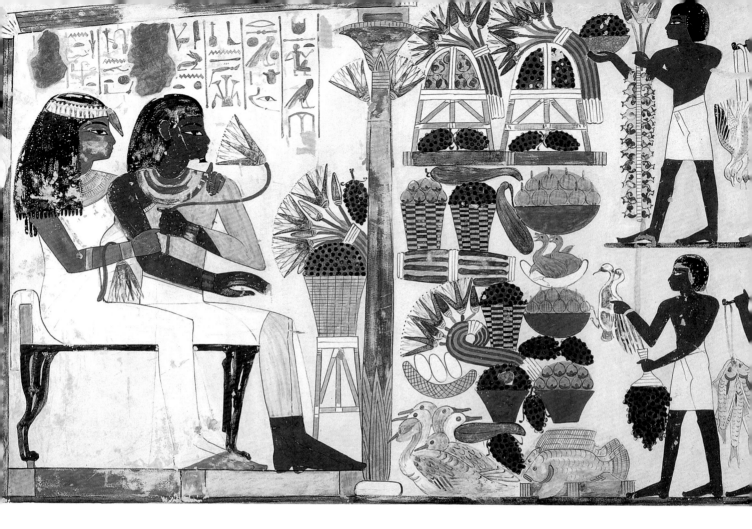

found by those painters who wanted to let the deceased take the beloved garden pond
to the grave with him. The view from the ground, where one bank was closer than
the other could not be represented. In response the artists changed to a bird's-eye view
and represented the water and the fish from above, while they continued to depict the
surrounding trees from the side. Together with the water the trees appear to be lying
flat. This is the same 90-degree change of perspective which the Egyptians used when
representing people (ill. p. 11).

These problems of perspective did not apply to statues. They were typically only
meant to be seen from the front. The later Greek statues of warriors and athletes were
designed in such a way that beholders could walk around them. The artistic bodies
displayed ideal beauty from all sides. Many of the surviving Egyptian statues must
have come from narrow burial chambers. They served as substitute bodies in which a
person's life-force, "ka", could settle to receive sacrificial food for the deceased resting
in the tomb. It was not their beauty that was of prime importance, but rather their
religious function.

If the statues are compared with the pictorial representations it becomes clear that
they show more portrait similarities, more individualized heads than on the reliefs or
the wall paintings. A famous, early example is the so-called Sheikh el Beled (*Headman
of the Village;* ill. p. 20 top) dating from the Old Kingdom. It was carved sometime
between 2504 and 2496 BCE. It is an almost life-sized statue of the scribe and priest
Ka-aper. The round head seems to have been modelled from life. It is the head of a
man who was used to taking on responsibility. He exudes calm and dignity. Despite
this individualization the carver once again stuck to the canon, which dictated that

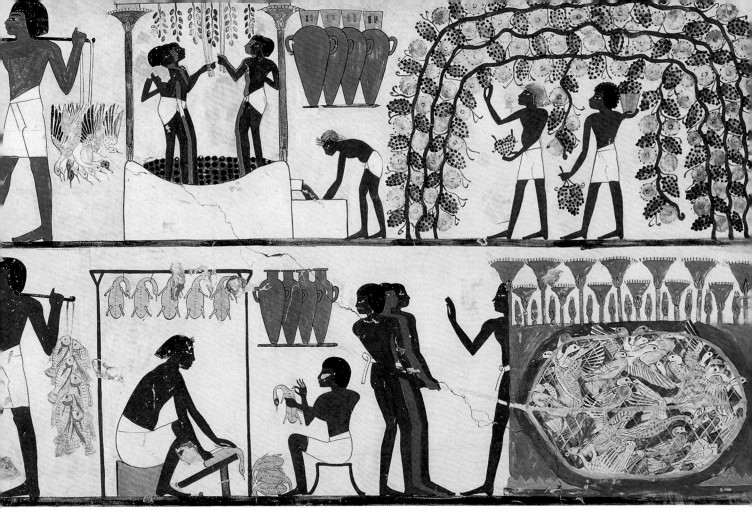

the arms should remain close to the body. This may have had practical reasons when it came to stone statues, but would not have been necessary for wooden statues where the arms were attached subsequently. Maybe a broad gesture did not conform to what was considered dignified or appropriate in the presence of gods.

Since most sculptures consisted of individual figures the concept of "sizing by importance" could not really be applied. People's rank could rather be represented by their pose. Those of the highest standing are usually sitting on a throne, a chair, or a stool. People of medium rank are often standing or walking, while people of even lower rank such as children or scribes were shown sitting on the ground. The sexes in turn were differentiated by the position of their feet and by their flesh tone. Women have a light yellow skin colour, whereas men were given a reddish-brown one. Women were shown with their feet close together, men on the other hand were shown striding along. This could mean that women looked after the house and the family, while men had to prove themselves outside of the home (ill. pp. 12/13).

Artists and Artisans
The men creating art at that time had different goals from artists today and those looking at art had different expectations. Today we care about novelty. In every exhibition we look for something we have never seen before or at least not seen before in that way. We expect further development, believe in the avant-garde, and look for a completely unique style which cannot be mistaken for that of another artist. Art is made for the open market, for collectors and dealers. Most artists do not know where their work will end up. In ancient Egypt the exact opposite was true. Art was commissioned and the

Wall Paintings in the Tomb of the Official Nakht, New Kingdom, 18th dynasty, c. 1395 BCE
Tempera on stucco
New York, The Metropolitan Museum of Art

As in a comic strip, different plots can be depicted next to each other and one on top of the other. In the top right, grapes are being harvested, then trampled by foot; bottom right depicts fishing and poultry-plucking. The size of the people corresponds to their importance: the tomb owners are larger than their servants, who in turn are larger than the workers.

13

Sketch of the Face of Senemut,
New Kingdom, 18th dynasty
On an ostracon from Deir el-Bahri,
height 9.3 cm (3¾ in.)
New York, The Metropolitan
Museum of Art

work was done at or for a particular place, such as a grave or a temple. The most important skill an artist needed was to be able to bring life into a work. The Egyptian word corresponding to our word "artist" can be translated with "the one who brings to life". The people an artist depicted were brought to life with magic spells. This was true of the grave's occupant as well as for the family members or servants who were supposed to accompany, delight, and feed the deceased. The images were also given magic powers. If for example papyrus and lotus were bound together on the temple walls as an allegorical unification of Upper and Lower Egypt, then this was considered an invocation of unity and a magical insurance against a sundering of the two kingdoms.

No one commissioning art expected anything new. Instead artists were expected to make use of the established, venerable motifs that had been collected in pattern books. If something new really was meant to be built or incorporated into a picture, then the pharaoh gave the specifications or occasionally the architect he hired did, such as the famous Imhotep for example. His name is inscribed on a statue of King Djoser, who died in 2670 BCE (ill. p. 14 bottom). Imhotep created a step pyramid for Djoser by placing successively smaller mastabas, the customary low tombs of the time, on top of each other (ill. p. 28). This was one of the precursors of the final pyramid form. Imhotep was credited with many wise aphorisms. Scribes of subsequent generations offered him a drop of water before they started work and during the Late Period he was worshipped as divine. Imhotep was also, if not an artist in the modern sense, a "designer" of royal power and the oldest personality known by name to have had an influence on a pharaoh's cultural surroundings.

A man of doubtless similar influence lived a good 1,000 years later: Senemut (ill. p. 14 top), the treasurer of Queen Hatshepsut, tutor of her daughter, and architect of her funerary temple located at the foot of a 300-metre-tall rock. He was surely partly responsible for the lavish programme of images and organized a tomb for himself below his queen's temple. The pharaohs' architects had a high social standing – they were "respectable". As artisans, however, the artists who actually executed the work were quite low down in the social hierarchy. Occasionally their name or a sentence has come

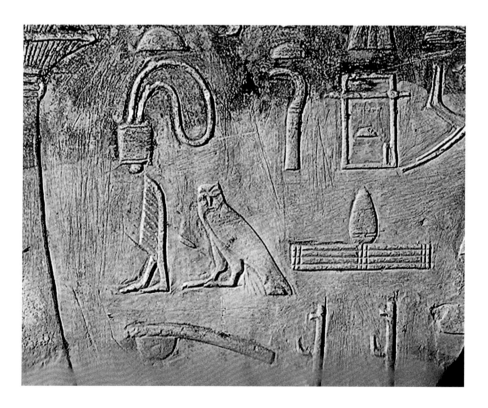

Imhotep's Signature,
Old Kingdom, 3rd dynasty
On the pedestal of the limestone
statue of Pharaoh Djoser

down to us, but it is the exception that a connexion can be made between a name and a work. Probably the oldest words about art are in the "Precepts of Ptahhotep", a vizier in the Old Kingdom. Words that indirectly express the longing for the perfect work: "For the barriers of art are not closed, no artist being in possession of the perfection to which he should aspire." A stele of the 11th dynasty of the Middle Kingdom contains the proud words of a certain Irtisen: "I know… the correct calculation so that… a body will go to the right place… I know the secret of the holy words… I have used every magic power without any of it evading me, because I am truly an artist." Bak (ill. p. 15) is also proud, namely of his close contact to pharaoh Akhenaten: Bak, the "highest sculptor" described himself on his funerary stele as "one who was instructed by His Majesty himself". But it is not clear which of the surviving works dating back to Akhenaten's time can be attributed to this Bak. Of his contemporary and colleague Thutmose, by contrast, while we have no quotes, we know not only his name, but also his abandoned workshop in which studies for portraits of Akhenaten's family were found – people who in the meantime had been ostracized – including, as luck would have it, the now world-famous one-eyed bust of Nefertiti (ill. p. 73).

The artist-artisans were in the service of the court or the temples, but could occasionally also be commissioned by private individuals. They worked in teams (ill. p. 17 bottom). The walls in the rock tombs had to be smoothed or also coated with mortar. The contour draughtsmen drew horizontal lines with the help of string so that the people could be represented in the correct proportions, but also to divide the surface into different levels (as is now done with comic strips). If people and objects were drawn on the surface and the item was going to be a relief, the sculptors gouged out the contour lines. People and objects were softly modelled. Finally, painters were brought in to provide the reliefs with colour. The stone or wood blocks of statues were also marked with a network of lines to guide the carvers, which required constant renewal as work went on. A distinction was made between stonemasons who did the rough work and sculptors who formed and polished the statues.

Whether relief of statue, temple walls and columns – they were all painted. However, everything that was exposed to sunlight lost almost all of its colour over the centuries. Since Egypt has become an extremely popular tourist destination and many of the visitors want to see the rock tombs with their own eyes they are also now extremely at risk, because they are no longer protected by dry and dark conditions. Painters in Napoleon's retinue or those accompanying scholars and travellers during the 19th century thankfully recorded these colours. If we trust their representations, then the ancient Egyptians had temple walls and ceilings that were overly garish for today's tastes and do not fit well with our conception of ancient Egyptian dignity, calm and clarity. Most paints were obtained from minerals found in the soil. The black colour used by painters as well as by men and women for make-up was obtained from coal soot. Malachite gave painters blue and green, chalk and plaster made white, and as a binding agent a mixture of egg-white and glue was used. In today's vocabulary this is called tempera. The paints were applied with rushes, i.e. hard grasses whose tips had been chewed to make them softer. A painter's equipment included a pot of water, a mortar in which the pigment was ground with a pestle, and a palette with indentations for the paints that were turned into a paste with binding agents.

Colours were not just used according to aesthetic preferences. Most of them had symbolic significance or were traditionally connected to certain figures or objects. One example is the colour green: it was the main colour for the god Osiris, the lord of the underworld, also responsible for eternal life. The fertile land close to the river Nile became green shortly after the annual inundation. Green stood for life, prosperity, and resurrection in the underworld. The figure of Osiris was often not just coloured in green, but also in black as a symbol of the underworld, his mythical realm.

Lighting posed a particular problem for the necropolis workers in the Valley of the Kings. Only in the outer rooms could they chisel and paint with natural light. Further

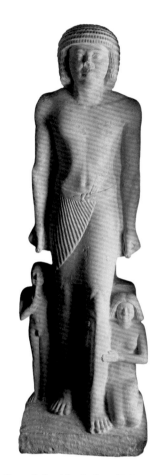

Grave Stele of the Sculptor Bak,
Old Kingdom, c. 2240–2200 BCE
73.5 x 23 x 25 cm (29 x 9 x 10 in.)
Berlin, Ägyptisches Museum

inside they had to depend on oil lamps. The death of a pharaoh always presented a particular challenge, since the "house of eternity" then had to be completed within seventy days. This was how long the embalming process took. In addition a successor would want to start on his own tomb. The increased demands were rewarded with added gifts. Ramesses II proclaimed: "Oh you accomplished workers, who are not lazy, who are alert in your work and fulfil your duty both efficiently and faithfully, hear what I have to say to you: your provision will overflow, there will be no deprivation… because I know your truly laborious work, during which a worker only cheers when his stomach is full."

The Lives of the Grave Workers

Time and again it has been put about that once a tomb had been completed the workers who built it were put to death because they knew the entrances and could have stolen the valuable grave goods. There is however absolutely nothing to substantiate this. Furthermore the succeeding pharaoh needed the specialist teams to construct his own tomb. All the same, royal grave workers were the bearers of secrets and to be able to control them more easily at the beginning of the 18th dynasty their masters housed them with their families in a village to the west of Thebes. Today its Arab name is Deir el-Medina. The foundation walls are still standing. A thicker wall surrounded the houses, which were closely packed. Two gates were guarded by Nubian sentries. Archaeologists have excavated doorposts that still had the names of the occupiers written on them in red paint. Here lived the artisan Sennedjem; opposite, the scribe Ramose. The number of inhabitants fluctuated. The average must have been around seventy artisans and together with their families they must have numbered around 500 people in total. The place existed for all 500 years of the New Kingdom. When the royal necropolis was then moved from Thebes to Tanis in the Nile delta, the village was abandoned.

However, the village archive, or parts of it, survived, hidden in a well. It consisted of papyri, but mainly of clay shards and stone chips. These ostraca, as they are known, served as cheap material for jotting down sketches, plans, and lists. It is because of them

"Can you see anything?" –
"Yes, wonderful things…"
— DIALOGUE BETWEEN LORD
CARNARVON AND HOWARD CARTER
IN 1922, ON FIRST LOOKING INTO
TUTANKHAMUN'S TOMB

that we are better informed about the lives of the artist-artisans in the Valley of the Kings than we are about those of their masters. On a path still extant today they made their way from Deir el-Medina over the mountains, the dwelling place of the goddess Meretseger, "she who loves silence", to their place of work. The path was too long to walk on a daily basis, so the men slept in temporary huts during their ten-day stints. They worked two four-hour shifts each day, between which they had a lunch break. On the tenth day they returned to their families. The issue and return of the valuable tools made of copper or bronze was exactly recorded. They belonged to the pharaoh. Even the degree of wear was measured. Ten pointed, copper chisels were worth approximately the same as a worker's annual ration of corn. The workers were paid in grain each month: "The foreman 7½ sacks, the scribe 7½ sacks, 17 workers 5½ sacks each, the two boys 2 sacks each, the guard 4½ sacks, the maids 3 sacks between them, the gate keeper 1½ sacks, the physician 1½ sacks…" No distinction seems to have been made between artists and artisans. When someone was absent from work it was also recorded. A certain Neferabu did not come because he had to embalm his brother, one Wadjmose was absent because he was building his house, Pendua did not show up because he wanted to go drinking with his friend, and another did not come because his wife had beaten him so severely he was unable to work. Common reasons for being absent were eye infections and scorpion bites. Brewing beer for festival days was also an acceptable excuse.

Chief overseer over the building works was the pharaoh's vizier. There were the occasional difficulties with his staff, as is also clear from the archive finds. They record a strike. The workers, artisans and artists marched to the Ramesseum, which was not just Ramesses II's funerary temple, but with its warehouses also the administrative centre of west-bank Thebes. They staged a sit-in in front of the temple gate and demanded their payment that had been due for the past month. They cried: "The prospect of hunger and thirst has driven us to this." When nobody took any notice, they returned the following day. This time the temple precinct's chief of police delivered the demands to the mayor of Thebes. Again they had no success. On the third day they cried: "There is no

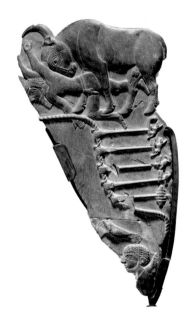

Palette au Taureau, Make-up Palette, c. 3400 BCE
Abydos, Naqada III period
Greywacke, height 26.5 cm (10½ in.)
Paris, Musée du Louvre

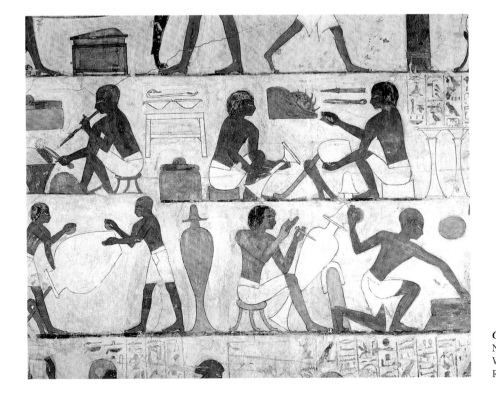

Craftsmen at Work,
New Kingdom, c. 1400 BCE
Wall painting from the grave of
Rekhmire, Thebes, Valley of the Kings

clothing, there is no fish, there are no vegetables. Send to Pharaoh, our good lord, about it, and send to the vizier, our superior, that we may be supplied with provisions." Only this request or the implied threat to inform the central administration had an effect. This occurred in November 1153 BCE. It is probably the first officially recorded strike in human history. It shows Egyptian society from a side different from the one we find in the tombs and temples.

Those ostraca depicting scenes from home and work also provide us with a more realistic image than the one presented to us in the religious sites: a naked girl with unmade hair who is bending down to tend to the fire in an oven (ill. p. 16), a woman sitting, breastfeeding her child, the head of a donkey, an ugly bald-headed man working on a wall with a chisel and a wooden mallet, a graceful dancing-girl flipping over backwards. Or the profile of a man where we can still discern the square network meant to make it easier to transfer the image on to the wall to the correct scale. We have everything from rough scribbles to professional sketches.

In the late Old Kingdom people such as the artisans and their wives, daughters, and servants were also represented in small statuettes, chiselled from limestone and not normally taller than 16 centimetres. They were used as grave goods and had the purpose of ensuring that the agricultural and domestic work would be seen to. One woman for example is kneading mash in a high vat to make beer. There is a statuette of a baker holding his hand in front of his face to protect himself from the heat of the oven. Or a careworn woman with sagging breasts who is squatting in front of a loaf of bread. Elderly women do not appear in graves and temples. Men and women copulating only occur on mocking ostraca, in erotic papyri, but also in the unofficial art of the Late Period.

A convergence of religion and everyday life can be seen in the graves of the artisans. They helped each other carve their own tombs into the rock and decorate them with frescoes – not so magnificent and highly stylized as those intended for the members of the royal families, but with a visible desire to surround themselves with the pleasant side of their own lives at this "place of eternity". In the pictures left behind by the pharaohs buried in the Valley of the Kings, they are consorting with the gods, the craftsmen are ploughing their fields behind their oxen, are harvesting their grapes, and are proud of their cattle, while the daughter is holding her favourite duck in her hand, and a woman is sitting with her child wrapped in a blanket under a tree bearing fruit.

The Nile and the Old Kingdom

Grave pictures show men harvesting the fields or hunting in papyrus thickets, but never the wider surroundings. No interest is shown in the landscape, the Earth's surface, or the climate in the face of eternity and the underworld. If any of these things did appear in their pictures then only indirectly. To be precise, there were only two things – an element and a celestial body, both givers of life and death: sun and water.

Egypt is a desert country and only four percent of its area was populated (map p. 94). The animating or killing power of the sun becomes clear through the gods. They were assigned to or identified with it. Both in graves and on temple walls the sun was one of the constantly recurring pictorial motifs. It was also constantly depicted on necklaces and bracelets and their wearers hoped to use it to ward off harm or bring about good. In contrast the populated part of Egypt is made up of a riverine oasis reaching from the Mediterranean coast to the first Nile cataract south of Aswan. It is a good 1,000 kilometres long and in some places hardly 100 metres wide. The river bank area was inundated once a year with a flood wave, which made the land fertile through the minerals the flood waters contained. Egypt owes its existence to a single river. Around 450 BCE the Greek traveller Herodotus wrote of Egypt that it was "a land won by the Egyptians and given them by the Nile". Without the Nile the early civilization would not have arisen and without the Nile neither would the modern state of Egypt exist.

The Nile was also the country's main transport route. Correspondingly important were the boats, the smaller ones made of papyrus stems tied together, the large ones

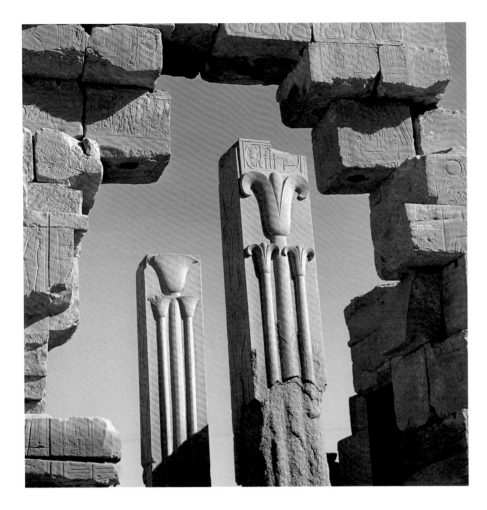

Armorial Pillar of Thutmose III with
a Representation of Lotus and Papyrus,
New Kingdom, 18th dynasty
In front of the barque shrine of the temple
of Amun in Karnak

made of cedar that had to be imported from the Lebanon. The facts of real life shaped their religious beliefs: the gods also travelled by boat, the sun god and his divine companions travelled in a barque across the sky from east to west in the day and at night he travelled back on the river Nun through the underworld. Of course the gods living in the temples were also carried to the Nile in barques and put on to the water on festival days. The Egyptian kings also had their own barques in the "place of eternity": in 1954 archaeologists discovered more than 1,000 separate pieces in an underground chamber next to the Pyramid of Cheops that could be assembled into a riverworthy barge with a cabin. This royal barge is 43 metres long and can now be seen in a museum above the place of discovery.

This is why boats with their curved lines and high-stretched bow and stern can be seen so often in Egyptian art. In contrast to the boats, the flooding of the fertile land – the most important event of the entire year – is never depicted in images. Maybe this was because it was transient, not something that could be linked to eternity. The sight of the land disappearing in the water only to re-emerge again did however shape the Egyptian creation myth and was handed down to us in words. In the beginning, so it is said, there was nothing but water and mud, an unformed mass. From it a hill emerged, something solid, something formed – the Earth, Egypt. In another version the Earth hill did not emerge by itself, it was brought up by Atum, the creator god, who also created the first divine couple through masturbation: "I sneezed out Shu and spat out Tefnut." Shu was the god of air, light, and life, while Tefnut was the goddess of moisture. A certain resemblance to the creation myth of the Old Testament that was written down later cannot be overlooked. According to Egyptian belief this primordial mud was not

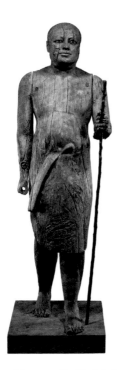

Ka-aper, Known as Sheikh el-Beled (Headman of the Village), Old Kingdom, 5th dynasty, c. 2504–2496 BCE
Wood, height 110 cm (43¼ in.)
Cairo, Egyptian Museum, from mastaba of Ka-aper in Saqqara

Priests could be recognised by their shaven heads; this one was called Ka-aper and was also a high official. As a sign of his rank he is carrying a cane. Since the gods determined the well-being of the land, there was no conflict of interests in serving the state and the temple at the same time.

something of the past, but still present in the underworld. For that reason the columns in the temples often end in a calyx – they represent the plants growing out of the primordial ocean supporting the roofs (ill. p. 19). The temples are thus considered to be the original hill and the place where the world was created. That is probably also why the wall surrounding the Dendera Temple complex was built in a wave-pattern: it follows the underground surges.

The start of Egypt's real history could be dated to around 5000 BCE, when nomadic hunting tribes settled on the banks of the river Nile. In around 3000 BCE the lords of Upper Egypt created a central state, built Memphis (near Cairo) and made it into the royal residence. Hieroglyphs were developed just a short while beforehand. Small figures, decorated pots, and make-up palettes have all survived from that time. These palettes were not meant for profane beautification, but for the ritual painting of the eyes (ill. p. 17 top).

In around 2707 BCE the period called the Old Kingdom began. The Old Kingdom ended after more than 500 years in around 2170 BCE. Dates like these outline periods that exceed our imagination and readers who only want to get to know individual works in this book should not burden themselves with dating. However, those readers who are looking for an overview, and want to recognize associations and changes in Egyptian art, will find the arrangement into "kingdoms" and "dynasties" helpful. It has to be said at this point that many dates are not certain. This is not only because they lie so far back in time, but also because of the absence of year one. The count was started anew with every new pharaoh. Officials would say things like "in the seventh year of the reign of King Djoser…" Later historians strung the regnal periods together. If a mistake occurred this seventh year would shift either forwards or backwards. Annual lists are already known from the Old Kingdom. The oldest known beginning for a chronology dates back

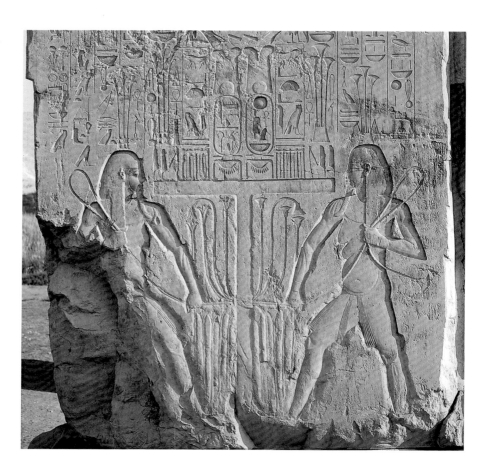

Binding Together Lotus and Papyrus as a Symbol for the Unification of Upper and Lower Egypt, New Kingdom, 18th dynasty
Relief from a pedestal of one of the Colossi of Memnon in Thebes

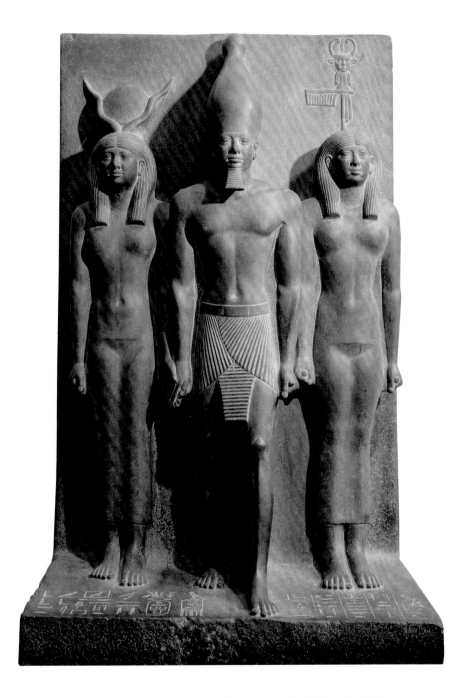

King Menkaura between Hathor
and the Nome Deity of Diospolis Mikra,
Old Kingdom, 4th dynasty, c. 2460 BCE
Greywacke, height 95.5 cm (37½ in.)
Cairo, Egyptian Museum

to the third century BCE and was written by a priest called Menetho. Only excerpts from his work Aegyptiaca have survived in copies, amongst them a list of the pharaohs. During the first centuries of the Common Era this list was completed and revised and this process is still going on today. Even if Egyptologists have largely agreed on a certain dynastic and number order, parts of it still remain provisional.

The literally most prominent creation of the Old Kingdom was the pyramid. As an artistic craft it was however, above all, the relief that was perfected during the Old Kingdom. In contrast to Greek reliefs, where the figures were worked three-dimensionally almost like statues, Egyptian reliefs basically remained a form of two-dimensional art (ill. p. 20 bottom). Composition and style resemble those of paintings. There were two forms: in raised reliefs the surrounding area was chiselled away, while the figures stood slightly proud of the surface; in sunken or incuse reliefs, the figures were modelled in an equally shallow manner, but the surrounding area remained intact. Sunken reliefs with

deeply cut lines created a strong shadow effect and for that reason were popular on the outer walls of temples exposed to sunlight. Thus for example the pharaoh who is swinging his war club above the heads of the captured enemies (ill. p. 53). The contours were first applied in red and then refined in black. The high-relief wooden panel depicting *Hesy-Ra at the Dining Table,* dating from the 3rd dynasty (ill. p. 31) is a masterpiece of the time, both for its contour design and its workmanship. The grave of Ti, dating from the 5th dynasty, contains a relief that still has parts of its colouring and in the section called *Return of the Herd* (ill. p. 39) beholders can study how painters and sculptors shared the work in complicated situations.

If we look at the figures' postures and facial expressions in the Old Kingdom then we often come across an expression that can be described as matter-of-fact optimism. Full of self-confidence and trust they look towards the future. This is true of King Menkaura (Mykerinos) and the goddesses accompanying him (ill. p. 21), but it is also true of the scribe Hesy-Ra and the so-called Sheikh el Beled (*Headman of the Village;* ill. p. 20 top) or also for the *Anonymous Couple* carved out of acacia wood (ill. p. 37). Worry and doubt are absent, the people seem to feel safe in a state that is ruled and kept in order by god kings. Things were not to stay that way.

The Middle Kingdom

The Old Kingdom collapsed, new men vied for power, regional princes fought each other, and the artistic canon lost its binding strength, as is always the case in tumultuous times. It took a good 100 years until a new ruling dynasty could establish itself and the old order could be restored. Egyptologists call this the First Intermediate Period and date it from 2170 to 2020 BCE. This period was followed by the Middle Kingdom. The old body of rules on artistic design came into effect again, but new things had entered the canon. They are only nuances and they probably reflect a changed attitude about the world. The upheavals of the Intermediate Period shook the trust in an order created by the gods and maintained by a divine pharaoh. After the pharaohs had been demoted to god-sons they came closer to human beings. As human beings they were subject to the aging process. This becomes clear from the *Sphinx of Senusret III* (ill. p. 45). His lion's body demonstrates superhuman powers, but his facial features are clearly marked by the weight of years.

He is far removed from an Old Kingdom figure such as King Menkaura who stands between two goddesses as if they were all siblings. Another sign of mental change is also that the upward orientation became supplemented by a downward one. The belief in pyramids as ladders to heaven waned, while interest in the underworld and its ruler Osiris grew (ill. p. 23). This was not only caused by a darkening of their world view, but also – strange as it may sound – by a growing self-confidence of the elites.

At one time it was only kings who could rise to heaven. The paradise of the underworld however was open to all who passed the Judgement of the Dead as "justified". It was not just kings, but many others who had a right to eternity.

The invention of the "cube statue" can be traced back to a rise in social standing of the elites during the Middle Kingdom, of the administrative officials and their families. This cube statue consists of a man squatting on the ground, whose body, wrapped in a cloak, forms the shape of a cube. Only the head sticks out, while the hands placed on top of each other are hinted at. The cube statue is an invention that may be placed close to the pyramids and the obelisk, if not by dint of its size, then of its quality and its brilliant simplicity. The cubes are around half a metre high and they were invented because privileged men obtained the right to erect statues of themselves in temples. If they were not squatting on the ground, they had themselves depicted as sitting low down, but still wrapped in a tight cloak. The accentuated body covering may have been a sign of devotion, of modest reticence in the sacred location.

A new development during the Middle Kingdom was the increased emancipation of painting from the relief. This is a consequence of the change from mastaba tombs to

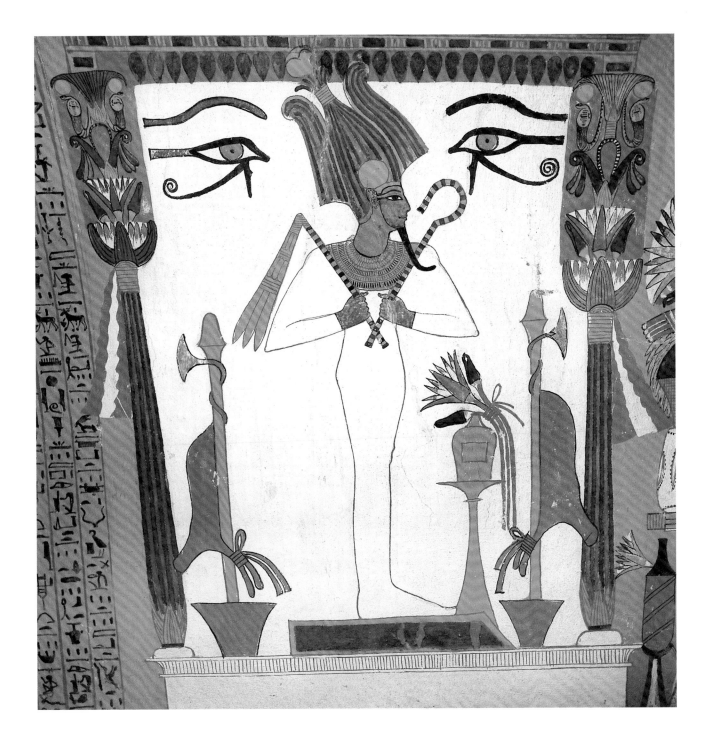

rock tombs. Paintings of the highest finesse in terms of colour were created on the smoothed walls. The Middle Kingdom became famous in the subsequent periods because of the elegance of its figures. The wooden grave statue of Imertnebes is a good example. Her putting a foot forward contradicts the rules, the wig seems too big, so it may be that it was meant for another figure. The slim body however is of eternal beauty and the diaphanous gown ending below her breasts shows them as if they were naked. It is also possible to see Imertnebes as an analogue to the hidden bodies of the cube statues and also as one of the many testaments to the ancient Egyptians' natural relationship to sexuality. The sexual modesty later preached by Jews, Christians, and Moslems was unknown to the Egyptians.

Osiris, New Kingdom, 19th dynasty
Wall Painting from the Tomb of
Sennedjem, Thebes (TT 1)

Osiris is the highest judge in the Court of the Dead. As ruler of the underworld he wears the insignia of power: crown, flail and crook, but he has the immobile body of a mummy.

The New Kingdom

The Middle Kingdom ended with the coming of the Hyksos. To this day it is not entirely clear who is meant by this label, but it is likely that it refers to Semitic tribes who entered Egypt via the Nile delta region. They allegedly came to power without a fight. All the same they did bring horses and two-wheeled chariots to Egypt, and thus a new artistic motif, which later became particularly popular for representing pharaohs going lion hunting.

The Second Intermediate Period lasted around 100 years. The subsequent New Kingdom lasted approximately 500 years. Four dynasties are recorded during the Intermediate Period, but only three during the New Kingdom, showing that the latter was a long period of comparative stability. The borders were secured, areas in the south and the east were colonized with more or less permanent success, and there were no great social shifts, apart from an enhancement of the status of the military, as can be seen in graves and on temple walls.

During these five centuries of relative peace it was only Amenhotep IV, who changed his name to Akhenaten, who caused a radical break. He denied the plurality of gods and declared there to be only one god, Aten, visible as the solar disc. He turned the traditional Egyptian polytheism into a monotheistic religion. Scholars have debated the theory that Akhenaten inspired Moses, who left Egypt with his people, and thus Jewish and Christian monotheism. It is not impossible that Akhenaten's break with the traditional world of gods was not just religiously motivated, but also politically – in other words, that the pharaoh wanted to deprive the influential priesthoods of Thebes and Karnak of their power. A point in favour of this theory is that he moved his residence and thus also the religious centre from Thebes to Amarna, 370 kilometres further north. He declared that it was not the priests but he alone, the son of god, who knew the will of the one god and thus had to perform his cult every day.

Akhenaten ruled from 1351 to 1334 BCE. His monotheism remained an episode – the residence and religious buildings in Amarna were torn down and the images of the king and his family were destroyed wherever they were found. However a few items

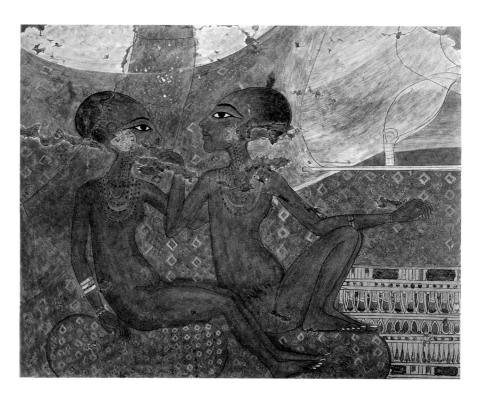

Two Daughters of Akhenaten and Nefertiti, 18th dynasty (Amarna period)
Fragment of a wall painting
Oxford, Ashmolean Museum

Two of Akhenaten's and Nefertiti's daughters with heads that are extremely elongated at the back. This was one of the characteristic features in representations of the royal family.

survived and are now amongst the most interesting artistic documents of the New Kingdom. They are interesting because of their deviations from the canon and also interesting because they show that it was the king who determined the shape of art. Because only Akhenaten himself could have ordained that he, the king, against every tradition, should be depicted playing with his children, that the rays of the sun should end as hands touching the royal family, and that he and his daughters (ill. p. 24) be depicted with monstrous backs to their heads. He himself was displayed with almost feminine body shapes as if he wanted to create a new human ideal.

Akhenaten's wife was the beautiful Nefertiti, whose famous bust was found in the depository of a sculptor's workshop. His successor-but-one was Tutankhamun, the pharaoh who died so young. His almost untouched tomb discovered in 1922 is one of the richest finds in Egypt. His tomb, like 62 others, lies in the Valley of the Kings. Added to that are the 88 graves in the Valley of the Queens and well over 400 tombs in the hills on the edge of the desert that belong to members of the elite. Together the graves form a unique necropolis. It lies to the west of what was once Thebes and is now Luxor. This rocky area is also unique for those who like to imagine what inconceivable amounts of gold, gemstones, statues, furniture, jewellery, and elaborately decorated sarcophagi were buried over the centuries. It must have been a sizable proportion of the national wealth that the grave robbers brought back into financial circulation – from an economic point of view, a meritorious service. Today it is a landscape of emptied treasure caves. Only wall paintings and reliefs have remained in situ, or at least some of them. Others have faded, been destroyed, or were removed and transferred to museums.

Many of the tools and items of furniture from Tutankhamun's grave, which can now be seen in the Egyptian Museum in Cairo, seem overcrowded and over-decorated, almost "baroque". They lack the simplicity, the reduction to essentials, that is characteristic of Egyptian art. A similar tendency to give and show more than previous generations can also be seen in the architecture. Every pharaoh built new temples and extended old ones, but during the 18th, 19th and 20th dynasties this need grew again and led to ever more monumental buildings. One of them is the Great Hypostyle Hall in Karnak with its 134 columns, some of them more than 20 metres high – papyrus stems turned to stone. The Great Temple at Abu Simbel, which Ramesses II had built for himself in the southern, Nubian part of the kingdom, is another example. Ramesses II surpassed all his predecessors of the New Kingdom in the number and size of his buildings. The thought comes to mind that this was a ruler who wanted to live out his craving for recognition. However, that alone cannot be the explanation. The temple buildings constructed by a king always also demonstrated, in their interior as in the border regions, the ruler's power. They were propaganda buildings that helped secure peace and order. Ramesses II ruled for 66 years, from 1279 to 1213 BCE – a long time, and his buildings were part of his government strategy.

The New Kingdom was followed by the Third Intermediate Period and with it the country's decline. It started around the year 1000 BCE. Most of the rulers only managed to hold on to power for a few years, and more and more non-Egyptians successfully claimed the throne, such as the descendants of Libyan mercenaries the Egyptians had brought into the country. Nubians controlled Egypt from the south, the Assyrians came, then the Persians, then Alexander the Great (356–323 BCE). After him the Greek-speaking Macedonian dynasty of the Ptolemies came to power. Their last representative, Cleopatra VII, committed suicide in 30 BCE, after which the country became a Roman province.

Not much can be felt of this political decline in the Egyptians' art. The foreign rulers maintained the religious system, had themselves made pharaohs, supported temple construction just like the earlier Egyptian kings, thus also supporting the creation of artistic works. Dendera, Edfu, and Philae are well-preserved examples. However, in other places, in the graves of the Greek colonists for example, the Greco-Roman Hellenistic

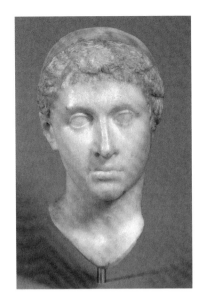

Portrait Head of a Woman, Possibly Cleopatra VII, c. 31 BCE
Alabaster, with traces of the purple primer for gilding, height 29.5 cm (11½ in.)
Staatliche Museen zu Berlin, Antikensammlung

style prevailed. The portraits of the deceased no longer idealized him for an existence in eternity, but showed him with all the fortuitousness of his current appearance.

There is a relief of Cleopatra VII, the last queen, with her son Caesarion in Kom Ombo, but as usual it is highly stylized and thus bears no portrait resemblance. Several coins with her profile are awful in their execution and contradictory in the details. What she looked like, this most famous of all the Egyptian queens, this woman who like no other inspired the imagination of the people for over 2,000 years and still continues to do so, nobody knows. Experts think a Hellenistic alabaster bust could be a representation of her. It is a head without a crown, without a wig. It is a well-proportioned woman's face, but completely without the majesty Egyptian artists bestowed on their rulers throughout the millennia (ill. p. 25).

Egypt in the Western World

The Romans adopted the Isis cult, imported obelisks, and built themselves funerary pyramids. During the Middle Ages Egyptian symbols played a role in alchemy in the search for an elixir that would help people obtain eternal life. However, for many centuries Europeans knew no more about the Egyptians than what was written about them in the Bible: the story of Joseph who gave the pharaoh wise advice and whom the pharaoh's wife Potiphar was unable to seduce, the ten plagues to which God subjected the Egyptians, the story of Moses who led the people of Israel across the Red Sea, or also the story of the Holy Family fleeing from King Herod's death squads to Egypt, a country about which nothing more is said.

An inquisitive interest in the distant country and its culture awakened during the Renaissance and reached its first peak several centuries later when Napoleon landed there in 1798. His troops were supposed to break the British domination in the Middle East, but they were beaten miserably. Napoleon did however bring over 100 draughts-men, technicians, geographers, and architects with him who measured the pyramids and temples and time and again also copied reliefs and wall paintings (ill. p. 6). The 20-volume *Description de l'Égypte,* a joint work of a number of authors, became one of the cornerstones of the branch of scholarship we call Egyptology. The second, even weightier cornerstone was the deciphering of the hieroglyphs by Jean-François Champollion with the help of the Rosetta Stone in 1822.

Champollion's insights were not just welcomed and acclaimed by experts. Interest in Egypt and the rest of the Orient kept growing and a kind of "Egyptomania" broke out – first in France, then also in Britain and Germany. The freemasons had already used both obelisk and pyramid as symbols, now women began copying Egyptian fashion by wearing long, flowing, diaphanous dresses with high "empire" waists. Furniture, plates, cups and long-case clocks were all decorated with trivialized god figures. Painters composed Egyptian scenes, in the 19th century, for preference, the death of Cleopatra as she lay seductively sprawled out.

At the same time a material culture transfer developed. European businessmen in Cairo or Alexandria purchased what the grave robbers brought them and offered the goods to European museums. This way large collections developed in Turin, Paris, London, and Berlin. A crime? The items were after all treated appropriately and have thus been better preserved than would have been possible in Egypt. In 1858 a Frenchman, Auguste Ferdinand Mariette, commissioned by the Turkish viceroy, founded a museum and made sure that important items remained in the country. Thus the large, extremely rich collection now on display in the Egyptian Museum in Cairo was created.

If Europe enriched itself through Egypt, it also gave back abundantly with scholarly examinations and sensational finds such as Howard Carter's discovery of Tutankhamun's grave in 1922 (ill. p. 27). These ventures were financed by private individuals, Oriental societies and universities. The greatest achievement however was not accomplished by Europeans alone. It was the saving of the temples at Philae and Abu Simbel from the rising waters of the dammed Nile, organized and financed by UNESCO.

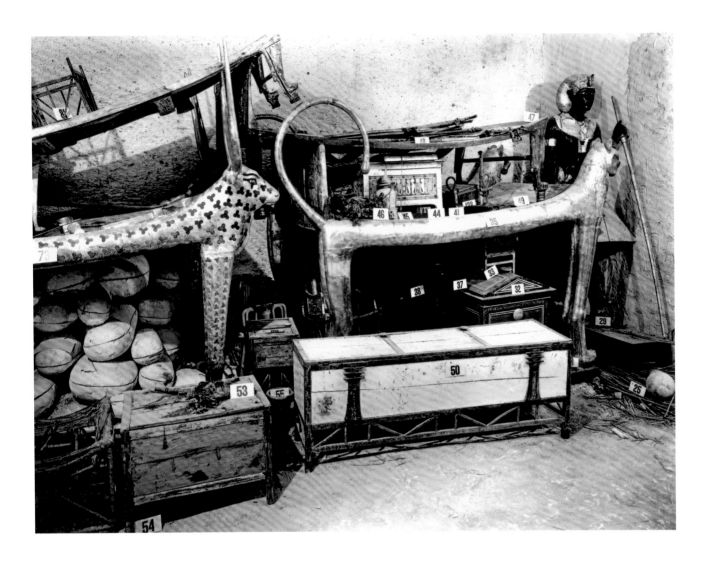

Nowadays it would be exaggerated to speak of Egyptomania; it would also be incorrect, because unlike in the 19th century the issue is not fashion and ornamentation. However, a constant, intense interest can be made out in far wider circles than usually occupy themselves with history and art. This is confirmed by many newspaper reports that make a big deal out of even the smallest discoveries in the Nile delta and it is also proved by the – in politically stable periods – well frequented exhibitions as well as the full tourist boats on the Nile.

Why is this so? Where does this interest come from? Phenomena in which masses or at least large numbers of people participate always indicate that something is missing. Thus it may be that we are missing something in our world and hope to find it in Egyptian art. This does not have to be a conscious process and nobody except maybe a few mystics will believe the old, spiritual Egypt could be brought into the present. What is it we are missing? What could it be? Maybe we long for art that is comprehensible, that simplifies complex process, and offers plausible formulas. Or maybe we long for a conceptually manageable society with firm borders, and a past that gives the present something to hold on to. Or maybe we want a heaven full of gods, youthful bodies right into old age, and after death a pleasant afterlife.

The Antechamber of the Grave of Tutankhamun, as Found by Howard Carter in 1922
Photograph

The rectangular white box, in front of the lion couch in the antechamber, contained, amongst other items, linen garments (shirts, shawls and loin cloths), 18 sticks, 69 arrows and a trumpet.

Old Kingdom, 3rd dynasty
King Djoser, c. 2670 BCE

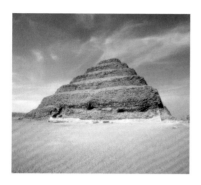

Pharaoh Djoser's Step-Pyramid,
Old Kingdom, 3rd dynasty,
c. 2690–2670 BCE
Saqqara

According to Egyptian mythology the gods themselves ruled Egypt in the beginning. Later, in what is known as the Old Kingdom, the rulers were the sons of gods. Although they were divine they were also – in contrast to the gods – mortal. Djoser was one of the first god-sons. This statue is considered to be the oldest life-sized sculpture of an Egyptian ruler. Even today the head communicates the impression of a personality that was more than just human. The king is wearing a tight-fitting cloak, his legs are close together, his right hand is placed in front of his chest, his left hand in his lap. The posture appears disciplined – it is that of a man who has a task to fulfil. It can no longer be said how much the head was stylized or displayed individual traits. It is damaged in various places. The eyes have been forced out – presumably they were made of gemstones – and parts of the nose and ceremonial beard are missing. The large wig and the royal headscarf covering it have both remained easily recognizable. The statue was painted.

Djoser is said to have ruled from 2690 to 2670 BCE. It is not because of special military or political actions that Djoser has stayed alive in the imagination of Egyptians, but first and foremost because of his grave complex in Saqqara, 20 kilometres south of Cairo. The Egyptians believed they would live on in their graves after they died. Pharaohs started building and furnishing them as soon as they came to the throne. In Djoser's time private tombs were flat buildings that look like benches from afar, which is why they are called "mastaba" from the Arabic word meaning "bench". Djoser was the first king for whom several mastabas were piled on top of each other. Each successive mastaba had a smaller floor plan and was reduced in height. In addition they were built of stone, and not of the air-dried tiles that had been customary until that time. Djoser thus got a 60-metre-high step-pyramid, which developed into the true pyramid form during subsequent generations. Thus the characteristic building of the Old Kingdom was created. It cannot be said for sure who invented the step-pyramid. It is usually not attributed to the king, but to his architect Imhotep. It was located in a large complex surrounded by a high wall. In it the buildings of the royal residence were recreated. Like all profane buildings the real residence was made of wood and Nile mud and has not survived. The grave complex on the other hand was designed to last for eternity and so it was made of smoothed stones.

The king's mummy lay in an underground cave far below the pyramid. The statue acted as its representative. It stood in a chamber next to the pyramid. The wall in front of the statue had two holes in it at eye level. Through them the king could see the sacrificial gifts that were brought to him, as well as observe the bright circumpolar stars, where the Egyptians believed the afterlife to be located. The tomb of Imhotep on the other hand has not been identified. There are no contemporary statues and his name is also only mentioned once in an inscription. However, his posthumous fame is greater than that of his king. He was credited with aphorisms and in his honour scribes would disperse a drop of water before they started work. During the Late Period he was worshipped as the god of medicine and healing and considered to be the son of Ptah, god of craftsmen. In the history of ancient Egypt hardly any names have come down to us of men who stood out for their intelligence or creativity. Imhotep, the man credited with designing Djoser's step-pyramid, is one of the few exceptions.

King Djoser, c. 2670 BCE
Limestone statue, height 142 cm (56 in.)
Cairo, Egyptian Museum

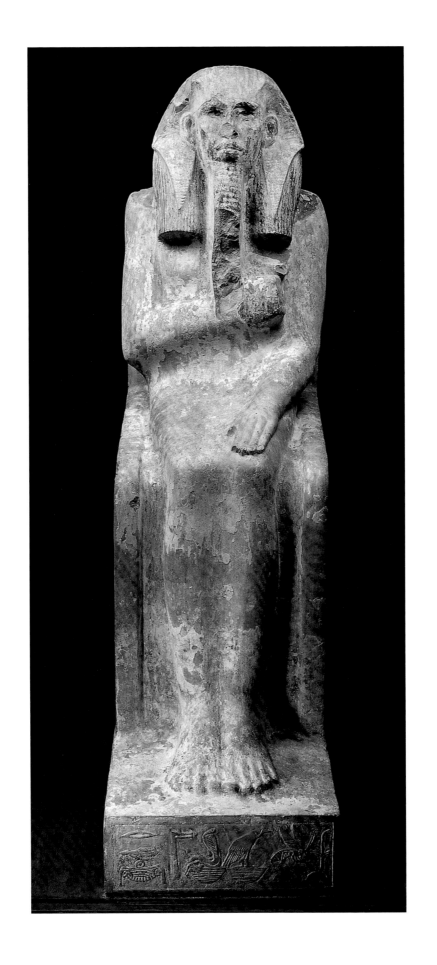

Old Kingdom, 3rd dynasty
Hesy-Ra at the Dining Table, 2690–2670 BCE

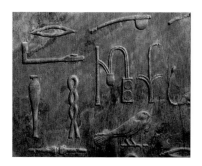

Hieroglyphs from the Tomb of Hesy-Ra (detail), Old Kingdom, 3rd dynasty, c. 2690–2670 BCE
Wood relief
Cairo, Egyptian Museum

The man with the striking profile and the curly hair is wearing a long sheath or quiver and a small sack over his shoulder at the back and a palette at the front. The sheath contains writing rushes, the small sack red and black chunks of pigment or water for preparing the paints in the round indentations on the palette. These were the typical tools of an Egyptian scribe. They immediately identified members of this important occupational category.

Every official's career began with his being trained as a scribe, since without records and accounting the complicated Egyptian administration would not have been capable of functioning. His titles such as "Governor of Buto", "Priest of Horus", and "Chief Dentist" are written above his image. The occupational descriptions declare Hesy-Ra's high social standing in the service of the king; identifying him by name guaranteed him individual care in the afterlife. The name was important, a portrait resemblance was not aspired to.

Hesy-Ra's rank in the administrative hierarchy is also attested to by the long staff of office and the club-shaped sceptre in his left hand. Hieroglyphs also identify him as "Great One of the South" and "Friend of the King"; thus he was high up in the official service of Pharaoh Djoser who ruled during the 3rd dynasty. In addition his tomb was located in Saqqara, not far from his king's step-pyramid. While the deceased was secure in an underground chamber, the complex above it consisted of a sacrificial chamber and a long corridor with eleven niches in which the relief shown here as well as further wood panels were located. Six of the original eleven wood panels have survived. They show Hesy-Ra in different poses, costumes, and at different ages. These are kept in the Egyptian Museum in Cairo.

During the Old Kingdom, the time of Hesy-Ra, the relief was – together with the statue – the most popular form for representing people and was created in several production steps by a team of craftsmen. First the outlines were sketched in red paint within a network of squares, then the final contours were laid down in black. Where the design stood proud of the background, the relief was made by first steeply carving the edges and subsequently working the background. As a final step the edges were rounded off and the figure was modelled.

Hesy-Ra is depicted sitting down on just one of the panels. A richly laden dining table with bread stands before him, above it hieroglyphs list among other things the sacrificial goods wine, meat and frankincense, all of which, even though only present as an image or an inscription, were intended to nourish him in the afterlife. The official is dressed in a long cloak that reaches to his ankles. It does not however cover his right arm and shoulder. While he is depicted in profile, the eye and the shoulders are shown from the front. This corresponds to the canon of Egyptian representation, which demanded that every part of the body be shown as characteristically and recognizably as possible. It was not the perspective view of the beholder that dictated how a person was depicted. The Egyptian artists were much more concerned with the correctness, the truth of the human being. All the different parts of the body were still treated very realistically and in great detail here. Later, this became the exception in Egyptian relief representation. While working within the framework of the strict canon, the artists were still able to give Hesy-Ra expression and character as a self-confident and authoritative dignitary.

Hesy-Ra at the Dining Table, 2690–2670 BCE
Wood relief, height 114 cm (45 in.), width 40 cm (15¾ in.)
Cairo, Egyptian Museum

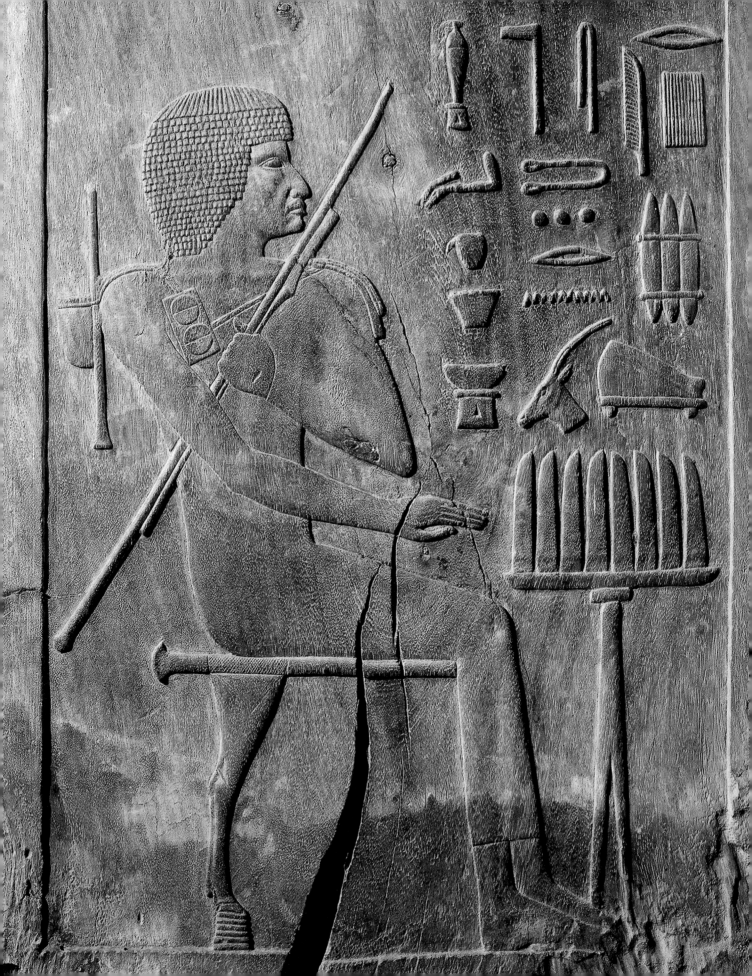

Old Kingdom, 4th dynasty
The Geese of Meidum, c. 2600 BCE

Three pairs of geese are grazing in front of a pastel-coloured background between flowering tufts of grass. This is probably the oldest surviving painting in the typical "Egyptian style", and its freshness and perfection still surprise us today. For this reason the picture could be thought of as the climax of centuries-long artistic development, but in actual fact it dates from the very beginning of Egyptian painted art. This frieze was painted as a grave decoration during the Old Kingdom under Pharaoh Sneferu, the founder of the 4th dynasty and the father of the famous Khufu (Cheops).

What at first glance appears to be a realistic depiction of nature is in truth strictly composed. This frieze already displays the features that were also characteristic of the Egyptian art of later centuries: stylization, idealization, and representation in profile. The six birds were not simply drawn in a line, they were symmetrically arranged. Two greylag geese with long wave-like, brownish feathers and red beaks are looking to the left with raised heads. Two red-breasted geese with scale-like, grey feathers and white beaks have their backs turned to them. On each side of the frieze one larger greylag goose is grazing with its head down, facing away from the centre of the frieze. All the animals have been portrayed from the side. They are ideal, perfect geese that fit into the afterlife fields of a grave decoration. Their arrangement into two groups of three surely is not coincidental: in Egyptian writing a plural is indicated by three lines or triple representations. *The Geese of Meidum* thus stand for an undetermined number of birds.

The frieze was discovered in 1871 by the French Egyptologist Auguste Mariette: it decorated a passageway leading to the burial chamber of Nefer-maat's wife Itet. Nefer-maat was the name of one of Sneferu's sons. It was Sneferu who had a pyramid

The Geese of Meidum
(general view), c. 2600 BCE
Stucco, painted, height 27 cm (10¾ in.),
length 172 cm (67¾ in.)
Cairo, Egyptian Museum

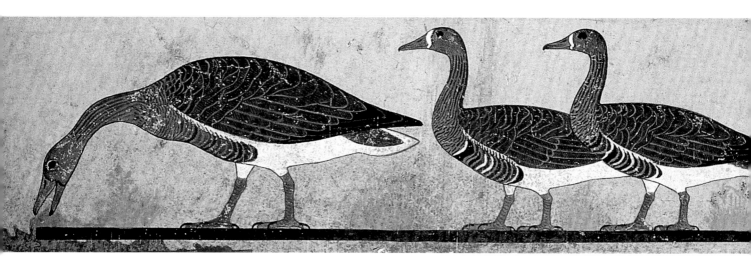

erected in Meidum, around 75 kilometres upstream from Cairo. This pyramid is now partially collapsed. Surrounding the pyramid are the brick tombs built for courtiers and officials. This is also where prince Nefer-maat and his wife Itet were buried.

In this same tomb is also the larger depiction of a goose hunt with nets in the Nile delta, in other words a scene taken from the Egyptians' everyday lives. This was something new: until then artists had been satisfied with decorating tomb walls with depictions of richly laid sacrificial tables. The piles of victuals also always contained geese, between all the legs of oxen, bread, and pyramids of fruit. They were a traditional gift to a deceased person, because they played an important role in the Egyptians' menu. The migratory birds were caught and fattened when they settled in the delta during the winter months. In the grave pictures servants are busy stuffing live geese with flour dumplings, and plucking dead ones.

Not only the style of representation but also the painting technique was only to change slightly over the following millennia in Egypt. The background consists of a light layer of stucco over a thick layer of clay plaster. The tempera paints were made from natural mineral materials: black from coal, blue and green from malachite, red and yellow from ochre soil. They were dissolved in water and bound by an emulsion of glue and egg white. The dark pink spot on the goose breast was created through a clever mixture of the two primary colours red and black. Egyptian artists did not sign their works, thus the name of the master of the Geese of Meidum is unknown.

"I know… the position of a captured bird."
— THE ARTIST IRTISEN ON HIS GRAVE STELE FROM THE 11TH DYNASTY

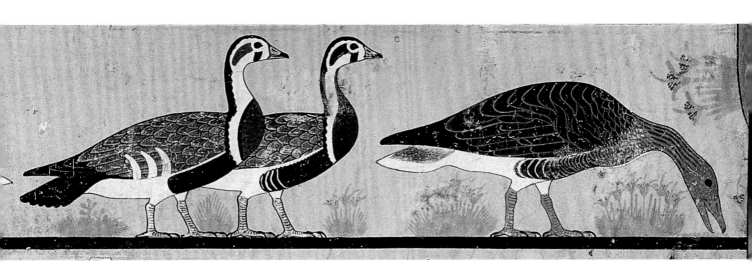

Old Kingdom, 5th dynasty
The Seated Scribe, 2500–2350 BCE

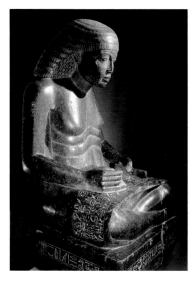

Statue of a Scribe of Amenhotep III,
New Kingdom, 18th dynasty,
c. 1388–1351 BCE
Cairo, Egyptian Museum

The scribe is sitting cross-legged on the ground. He has a papyrus scroll spread out over his knees. He is holding the rest of the scroll in his left hand. His right hand must have contained a brush. Papyrus scrolls were usually 1.5 to 2 metres long and up to 20 centimetres across. They were made from the stems of the papyrus plant, which were cut into strips and compressed together. The Egyptians wrote in vertical columns from right to left.

Several statues of this kind have survived; the bodies are all more or less the same, the heads on the other hand are individualized and often expressive. This scribe has a look of concentration. His mouth signals tense alertness. Only the highest personages sat on chairs, sitting on the floor demonstrated a serving function. However, the fact that an individual form, an individual representational formula, was developed for an occupational category demonstrates that it was important and highly regarded. Being able to write was the prerequisite for an official career and officials formed the backbone of the administration. Training took place in schools, but only a small minority of children had the chance to be accepted there. They learned hieroglyphs and the faster cursive style of writing, they learned the places and regions of Egypt, the names of plants and animals, the gods and their festivals, and the correct way to address members of the official hierarchy. "Wisdom literature" was used to teach them the correct way to behave, to be obedient to those higher up in the hierarchy, to be fair to those who were weaker, and most of all to teach them self-discipline: "Only the reserved are held in high regard and a man of character who is also rich asserts himself in the administration like a crocodile."

Egypt was an administrative state. In theory the pharaoh owned the entire country including its people – all the harvested food was handed over to him and he redistributed it. The situation in practice was different. The farmers kept an agreed amount for their own consumption, while taxes were levied on the number of oxen and the estimated harvest yield. The temple complexes included warehouses from which the collected food was distributed amongst the pharaoh's priests, functionaries and workers – in the tombs or at the pyramids, for example. The organization and provisioning of the thousands of men who, in changing shifts, built the pyramids in Giza is not conceivable without a highly qualified group of officials. Without scribes the annual inundation of the Nile would also have led to chaos. The flooded fertile land had to be surveyed anew every time the Nile burst its banks. Only through the annual flood was life on the river Nile possible, only with the help of the surveyors could the land parcels be established again.

In other ancient civilizations warriors were honoured and frequently depicted, but in the art of ancient Egypt they only appear rarely. The surrounding deserts made outside attacks more difficult and according to the ruler ideology the country's defence was always the job of the pharaoh. He himself would slay all enemies. In ancient Egypt it was not warriors and generals who were of the highest rank, but priests and officials. Often the two functions were combined in one person.

The Seated Scribe, 2500–2350 BCE
Limestone, alabaster, and rock
crystal, height 53.7 cm (21¼ in.)
Paris, Musée du Louvre,
found in Saqqara

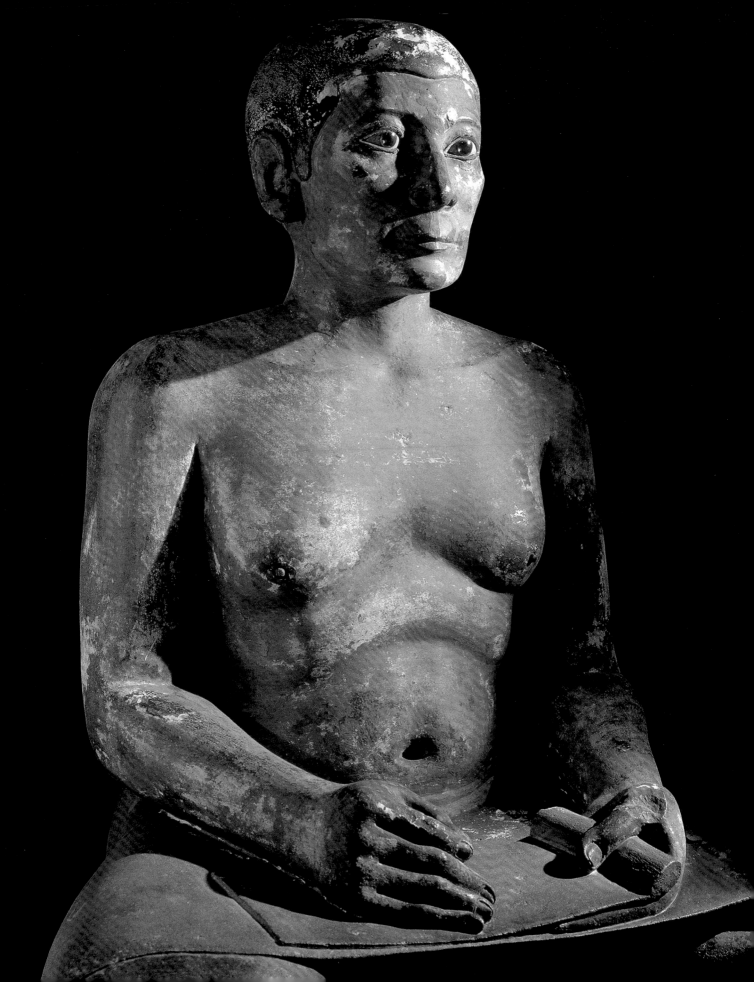

Old Kingdom, 5th dynasty
Anonymous Couple, 2500–2350 BCE

This couple were carved out of a single block of wood. The man, striding in front of his partner, was a high official: he is holding a papyrus scroll in his right hand. This identifies him as a scribe. The staff of office in his left hand is lost. He is wearing a simple loin cloth. The woman is wearing a long, tight dress that shows off the shape of her body. Its colours can no longer be determined. The semi-long wigs of the two were fashionable during the 4th dynasty. Their wide mouths and the pronounced eyelids in the finely worked faces are also typical stylistic traits of this period.

There is no inscription recording the names of the two people. The location where the statue was discovered is also unknown. It was acquired by the Louvre in 1826. It most likely came from a grave in Memphis and depicts the tomb's owner with his wife. Wood groups are rare; this is the only surviving wooden statue of a couple from the Old Kingdom. It has suffered a lot at the hands of insects and time. However, it is this damage in particular that has given the couple their expressiveness and buoyancy. Quite in contrast to most of the known heavy stone statues of Egyptian couples, this couple appear to be in motion, striding towards us, the beholders. Thus it shows us the optimism of a privileged society and a great era. The Old Kingdom lasted for approximately 500 years. It collapsed in around 2200 BCE, seemingly under pressure of social unrest.

This work presents the typical marital division of roles: the husband leads. Tall and strongly built, he has his left foot forward and is pulling his delicate wife behind him. She was sculpted to the same scale, but she is smaller than her husband. Her left arm is around him and she is modestly standing with feet together a little behind him. This corresponds to the artistic conventions. During the entire pharaonic period, Egyptian sculptures and paintings showed a similarly harmonious image of families and couples: most of the group statues have come from necropolises and were intended to secure the survival of those who commissioned them in the afterlife. For this reason they were shown to be young, beautiful, and happily united. This is a reflection of the ideal of Egyptian society, of order within a large system, defined by the rules of harmonious, "correct" living together in marriage and family.

The man was occupied in a profession, his wife had children and was called the "mistress of the house". She enjoyed more rights than women in other ancient cultures. However, the philosopher Ptahhotep had the following to say to men about the treatment of women: "…let her decide nothing, though, / keep her away from power and rein her in, / for a woman is a storm when she can do what she sees." In most afterlife depictions, too, a wife was shown to be "reined in", occasionally she was shown cowering at the feet of her husband in miniature format, while her mother-in-law sat majestically next to her son. Not always would a wife find even a spot in her husband's tomb. It was he who decided whether she would survive in eternity or not. He decided who he would take with him and who he would leave behind to be forgotten. Only very high-ranking ladies, queens, princesses, and priestesses owned their own grave.

Although on this statue the woman is standing a little behind her husband, who is striding forwards, she is nonetheless depicted to the same scale. "Ointment too is a remedy for her limbs," Ptahhotep further advises, "so use it to fulfil her desires while you live!" Maybe this touching couple does not just represent an ideal, but a real experience of togetherness.

Anonymous Couple, 2500–2350 BCE
Acacia wood, height 69.9 cm (27½ in.)
Paris, Musée du Louvre

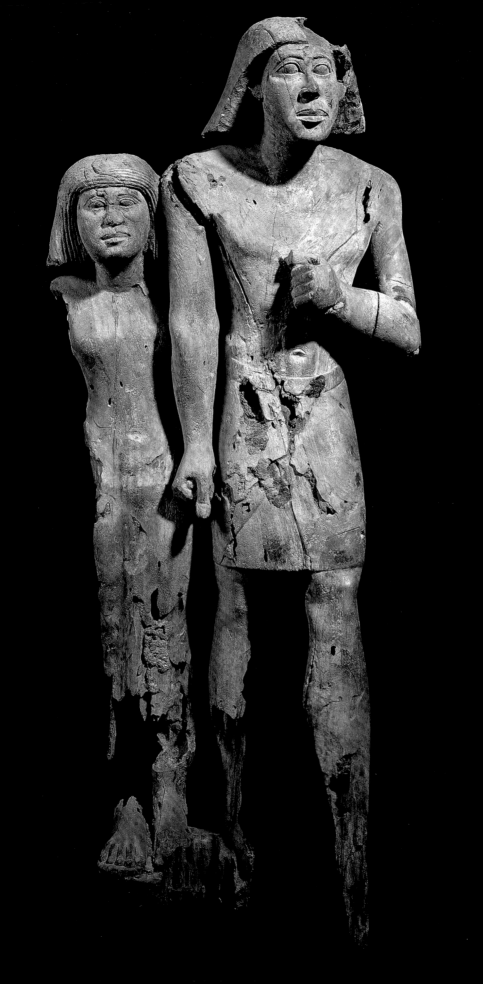

Old Kingdom, 5th dynasty
Return of the Herd, c. 2400 BCE

"I am a diligent official of my master in the fulfilment of my grain deliveries and the taxes… 3632 pitchers of wine were my quota through my staff, I had them bring 25,368 pitchers. 70 pitchers of honey were my quota, the honey that I brought was 700 pitchers… 70,000 sacks of grain was my annual quota, I brought 140,000…"

— REPORT OF AN OFFICIAL IN THE NEW KINGDOM TO HIS SUPERIOR

Ty was a high official, responsible for two pyramids and several sun temples. The pharaoh, who did not pay any wages, but who was – in theory – the owner of all the land of Egypt, left him the land. Ty became a big landowner. He wanted to feel the joys of his estates and his herds in the afterlife too. The walls of his mastaba show Ty and his wife watching the harvest workers, they show Ty standing in a boat hunting hippopotamuses and Ty hunting birds. They depict Ty together with his wife in a papyrus thicket. Time and again shepherds and herdsmen are leading sheep, oxen, and donkeys in large numbers across the image. The way artists represented the presence of larger numbers was by showing their bodies slightly staggered behind each other, as if the animals were walking in ordered rows like soldiers on parade. One of these animal formations shows three individual cows running ahead, led by a cowman carrying a calf over his shoulders. Instead of a schematic arrangement the artist created a lively scene of animal life: the presumably newborn calf is turning its head towards its mother, who has her mouth open, as if the two were engaged in a dialogue with each other. When looked at matter-of-factly it becomes clear that this method was a trick: the cowman used the calf to lure the mother cow through a ford, and the rest of the herd then followed the mother. Such a scene can only be depicted by someone who knows about animals, and it reminds the modern beholder, who always first thinks of pharaohs and pyramids, that Egypt was an agricultural society. Hunting did not play a major role; while people ate the fish in the Nile, they mainly lived by cereal cultivation and animal husbandry. The large majority of the population in some way or another lived closely together with animals.

The significance of animals in the lives of Egyptians is also reflected in their writing and literature. The picture character for "joy" is a cow, turning to look at her feeding calf, "pleasure" is a jumping calf. A "veterinary papyrus" has survived from the 12th century BCE. It describes diseases with which the oxen could become afflicted and how they could be cured. In a fairy tale, only a fragment of which has survived, a herdsman sees an unknown goddess standing in a body of water. He understands this apparition as a warning about the great flood. The Nile flooded large parts of the riparian zone at the time of the summer solstice. In the fairy tale the herdsman calls out: "You bulls, we are retreating! The calves should ride in the boat, the goats should lie on the deck… Bulls and cows should swim behind it…Nobody can hold me in this flood in a year when the Nile is high, who gives orders to the back of the country, when river and farmland can no longer be kept apart." The herd shown in Ty's mastaba is also making its way through water, stylized by the vertical zigzag lines. The hieroglyph for water is also a zigzag line, but written horizontally. Often the written characters and the image components resembled each other closely.

The work is a painted bas-relief, but only small amounts of the paint have survived. It is practically impossible to depict legs in water in an aesthetically satisfying way on a relief – the lines of the legs and the water would overlap confusingly. The artist solved the problem by limiting himself to merely painting the legs. Just as the calf scene contrasted with the schematic herd animals, the legs in the water show how Egyptian artists tried to reconcile their observations of nature with stylization.

Return of the Herd, c. 2400 BCE
Painted limestone relief
Saqqara, mastaba of Ty

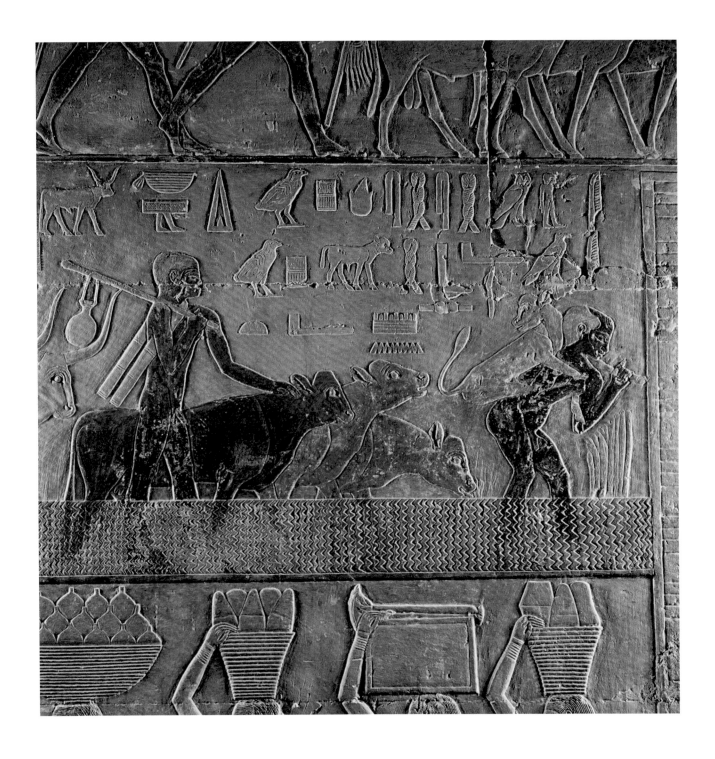

Old Kingdom, 5th dynasty
The Pyramid Texts of King Unas,
c. 2367–2347 BCE

Pyramid of King Unas, Interior,
Old Kingdom, 5th dynasty,
c. 2367–2347 BCE
Saqqara

Painted in blue, the colour of the sky, these characters decorated a pyramid's burial chamber. It is located in Saqqara, south of King Djoser's step-pyramid. It belonged to King Unas, the last pharaoh of the 5th dynasty. He was the first to have the walls of his burial chamber and his antechamber completely covered in inscriptions. They were carved into the white limestone wall cladding as incuse relief. The characters were worked very artistically. The Egyptians called them "god-words" and attributed their invention to the god Thoth, the "master of knowledge", often depicted with the head of an ibis. The Greeks were the first to call these Egyptian characters hieroglyphs, meaning "sacred writing" (from Greek: "hieros" = sacred, "glyphein" = write).

The inscriptions of King Unas, called pyramid texts, were not intended to be read. They served to immortalize, literally, what was written. They were religious dicta designed to accompany the ritual activities during the king's burial and to secure him eternal existence. Their subject was the ascent to heaven, Unas' return to the realm of his father, the sun god Ra, or his relocation below the stars. They talk about a heavenly ladder and about the pyramid, his posthumous residence. The building combines the earthly and the heavenly spheres.

Most of these dicta can also be found in the pyramids of Unas' successors, but after the end of the Old Kingdom, pyramid texts disappeared from the royal tombs. During the Middle Kingdom they were inscribed on sarcophagi and were also written down in late books of the dead; however they were then no longer ceremonial hieroglyphs carved into stone, but written in cursive script on papyrus.

The Egyptians invented their writing around 3100 BCE, shortly before their kingdom was created by the unification of Upper and Lower Egypt. The underlying reasons for its invention must have been mainly practical, administrative purposes, such as the determination and collection of taxes owed to the pharaoh. The kingdom's organization made it necessary to record and keep facts and to inform people in faraway places of them. Initially, scribes used ideograms, where the depiction of an object referred to the object itself: three pots registered three pots of oil paid to the pharaoh in taxes. Stylized representations of humans, animals, plants, and tools turned into hieroglyphs.

However, the need to record complicated issues led to the invention of phonograms, where the image of an object was used for a similar sound. The writing system shifted from the representation of semantic contents to the exclusive representation of sounds. Thus an image of a hare no longer referred to the animal, but to the sound "un", or rather "wn". The depicted text shows it several times as the beginning of King Unas' name (which, as the name of a ruler, was enclosed in a cartouche).

Writing was elite knowledge, because the writing system was not easy. Priests were always inventing new hieroglyphs and by the Late Period there were many thousands of them. They varied them, placed the characters from left to right or the other way around, as well as from top to bottom. Their arrangement was determined by aesthetic factors. After the end of the Egyptian kingdom hieroglyphs were forgotten. They were considered to be a secret magical writing until the French scholar Champollion managed to decipher them in 1822.

The Pyramid Texts of King Unas,
c. 2367–2347 BCE
Detail of a sunken relief
Saqqara, wall in the pyramid of
King Unas

Middle Kingdom, 11th dynasty
Grave Relief of Ashayt, c. 2030 BCE

Hathor as the Cow of Heaven with the Disc of the Sun on Her Horns
Painting from the tomb of Irunefer,
Ramesside period
Thebes (TT 290)

Grave Relief of Ashayt, c. 2030 BCE
Limestone, height 80 cm (31½ in.)
Cairo, Egyptian Museum, from the
mortuary temple of Mentuhotep II

The Old Kingdom collapsed, the provincial rulers made themselves autonomous and rivalled with and against each other until Mentuhotep II asserted himself as the new ruler in 2020 BCE. With him began the period that was later to be called Middle Kingdom. Mentuhotep II ruled for an exceptionally long time, 51 years. He had a magnificent mortuary temple built for himself in Deir el-Bahri. This temple complex included six graves for wives and daughters. One of them was Princess Ashayt. She died around 2030 when she was just 22 years old. When her mummy was discovered by archaeologists it was still lying in its wooden coffin. The coffin had stood in a stone sarcophagus; both the coffin and the sarcophagus had been opened by grave robbers in search of valuables.

An examination of the mummy revealed that the princess was somewhat corpulent, at least by no means as slender as she was depicted. The body the artist presented us with is an ideal. All members of the royal family, not just her, were always made beautiful on grave images. It is very rare that we see signs of age, and we never see signs of illness or decay. The deceased were represented for eternity, in light of which the current bodily state was irrelevant. As was customary in Egypt, the artist showed the figure in a double perspective – the eye and the shoulders from the front, everything else in profile. The contour lines so important in Egyptian art are worked formidably.

The princess is wearing a short, curly wig, a choker with pearls, and a close-fitting dress that ends under the breast and is supported by two straps. Her wrist and ankles are adorned with several decorative bracelets. She appears to be smelling a lotus flower. The lotus was a popular floral decoration and one of the symbols of reincarnation. As the lotus grew out of the water it was connected with the primordial water and mud from which the earth had once emerged, and since its blossom opened and closed with the beginning and end of each day it was also connected to the sun god.

In her right hand Ashayt is holding an ankh, the symbol for "life". It is unclear where this symbol came from. Some experts presume the bow on a sandal to have been the model for it, because walking or striding was considered as a symbol of being alive. The Egyptian Christians, the Copts, presumably took over the ankh as a symbol for life and hope of healing very much later from the ideas of pagan Egyptians. Several Christian symbols can be traced back to Egyptian models. Christ as a lamb and the Holy Ghost as a dove correspond to the Egyptian tradition of representing their gods in animal guise, the Holy Trinity of Father, Son and Holy Ghost may be based on the triads: the Egyptians believed a god could take on several appearances, usually three.

The relief of Ashayt was located on the outer wall of a chapel. On the front of the chapel the figure of a person making an offering and a cow with a calf could be seen. The goddess Hathor was depicted as a cow, as a woman with cow's ears, or as a woman's face with cow's ears. Hathor was a goddess particularly venerated by Ashayt's father. The princess herself served her as one of her priestesses.

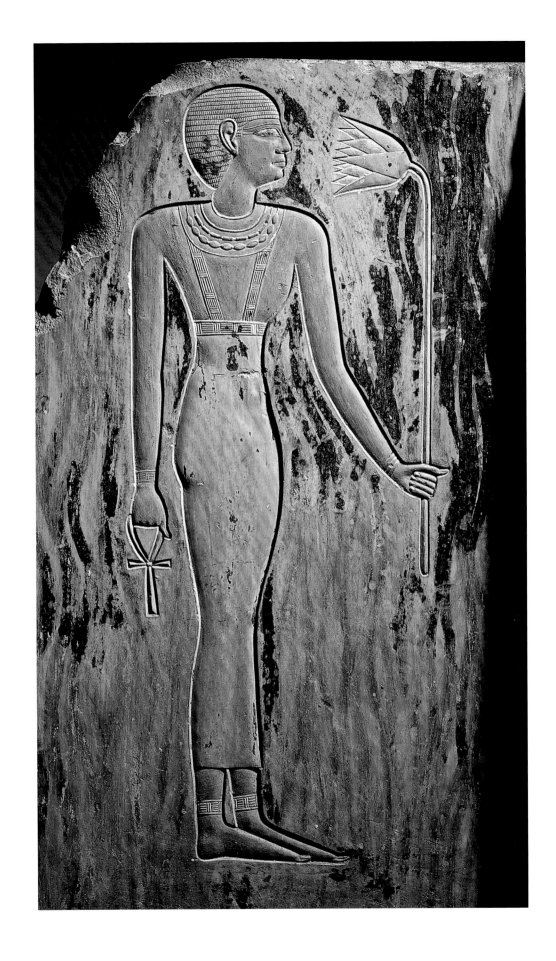

Middle Kingdom, 12th dynasty
Sphinx of Senusret III, c. 1860 BCE

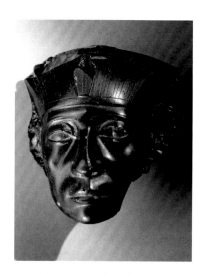

Head of Senusret III, Middle Kingdom,
12th dynasty, c. 1853 BCE
Obsidian, height 12 cm (4¾ in.)
Lisbon, Museu Calouste Gulbenkian

The sphinx was one of the great image inventions of the Egyptians. It was from them that neighbouring cultures took over this being that is half-human, half-animal. The Greeks turned the lion with a king's head into a female daemon with breasts and wings who killed any traveller incapable of solving her riddle. Oedipus knew the answer – and the sphinx leaped to her death. The Greek sphinx had a story, the Egyptian sphinx was a symbolic figure.

In any case this creature originating in Egypt is amongst the Western fantasy beings that have survived for thousands of years. Makers of horror films can still rely on its effect and every tourist visiting Egypt wants to look at the destroyed countenance of the Great Sphinx of Giza.

The Great Sphinx built by Khafra is over 70 metres long and 20 metres high. It was calculated to have an effect from a great distance; the sphinx of Senusret III is 73 centimetres long and may have stood in front of or in a temple. It also was not made during the Old Kingdom, but during the Middle Kingdom, around 700 years after its monumental predecessor. Both sculptures are missing their nose and the Egyptian cobra above their foreheads. Both heads are wearing the royal headscarf. The younger sphinx is missing its front legs, but to compensate has also kept its ceremonial beard.

Senusret III ruled during the Middle Kingdom. He was one of the pharaohs who re-established Egypt's centralized power after years of unrest, stabilized the country internally, and extended Egypt's influence outside of its borders. He probably ruled from 1872 to 1853 BCE, i.e. for 19 years. During that time he undertook a military campaign to Palestine and in several campaigns pushed Nubia's border further south. There he proclaimed his fame on steles and insulted his opponents: "My majesty has seen it… I carried off their women, I carried off their subjects, went forth to their wells, smote their bulls, I reaped their grain, and set fire thereto… I speak the truth, it is no boast that comes from my mouth."

Not just kings, but also gods were represented as mixed creatures. However, whenever gods or goddesses were depicted, the body was usually human and only the head was that of an animal. Maybe this was because arms and legs were needed to perform ceremonies, such as when the divine beings poured the water of life over a pharaoh. In those places however where the spirit and character were located, in the head and the heart, the Egyptians preferred their gods in a non-human form. The opposite was true for pharaohs. The head identified a person, while the lion's body symbolized super-human power.

The contrast between the body and face of the Senusret statue is striking. The lion part as well as the royal headdress and the ceremonial beard are highly stylized. It seems as if the stonemasons' goal was to make them look identical to earlier examples. This is not true of the face framed by the headdress. The energetic mouth, the lips pulled down at either side, the wrinkles that start at the root of the nose and end at the corners of the mouth: they are all marks of age and responsibility. In the face the artist-artisans were concerned with individuality and the pharaoh's current appearance – this was a divergence from the principles of Egyptian art and by no means the only one over the course of the centuries.

Sphinx of Senusret III, c. 1860 BCE
Diorite, height 42.5 cm (16¾ in.),
length 73 cm (28¾ in.)
New York, The Metropolitan
Museum of Art

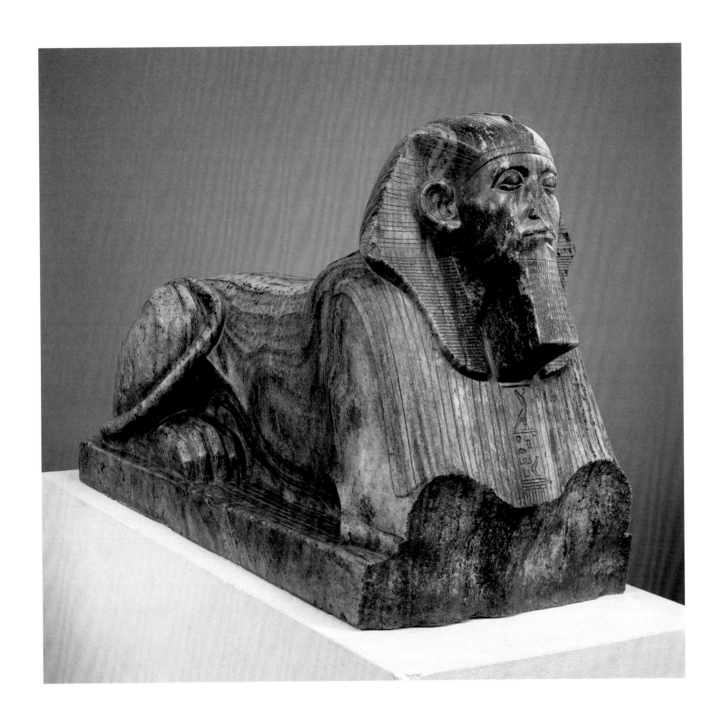

Second Intermediate Period, 13th dynasty
Ka Statue of Pharaoh Auibre Hor, c. 1750 BCE

The Shadow and Ba of Irunefer
Wall painting from the tomb of Irunefer,
Ramesside period
Thebes (TT 290)

This wooden statue has a striking headdress, consisting of a pair of raised arms with open hands that seem to indicate a defensive gesture designed to ward off evil.

The Ka Statue stood safe in a chapel-shaped wooden box on the floor of a shaft tomb in Dashur south of Saqqara. Several rulers of the Old and Middle Kingdoms had erected five pyramids here and this is also where the tomb of Pharaoh Auibre Hor, a 13th-dynasty ruler, was located.

The wonderfully preserved statue is only missing its sceptre and its staff of office. The pharaoh is tall and his left leg put forward as was customary. On his chin he has the long, plaited "divine beard" reserved for gods and deceased rulers. He is also wearing a three-part wig. The eyes are fascinatingly vivid. They are framed in bronze, while the whites are made of quartz and the pupils of rock crystal. The eyebrows, wig, and beard still contain traces of a gold-leaf coating, but the fine layer of stucco originally covering the statue disintegrated to dust when it came into contact with air. It was probably green, the colour of the Nile gods and other embodiments of fertility.

The statue's headdress – the raised arms with the open hands – is a hieroglyph for the term "ka", which is an individual's personified life-force. "Ka" sounded similar to the word for "bull", thus initially referring to male potency, then later to not just the physical, but also the spiritual life-force that influenced others. At the birth of every human child the creator god Khnum also created their ka on his potter's wheel. Thus the ka is part of its owner's identity and personality. It accompanied him or her as a kind of double, even after death, and ensured the deceased's continued existence through the acceptance of offerings.

Egyptian religion had no concept of our simple duality of body and soul. The one thing we call soul they divided into ba, akh, and ka. The mobile ba was able to get away from the deceased's body for a short time and occasionally sat as a human-headed bird on a tree in front of the grave. The akh could haunt the living. The shadow, heart and name were the other constituent features of a person's identity, and with them he had to face judgement in Duat after his death. However, the ka was the most important thing for people's eternal lives. It was needed for their continued sustenance and in the event of the mummified body being destroyed. Thus a ka statue was placed in the tomb next to the sacrificial chamber, to act as a substitute. It did not have to resemble the deceased physically, but it did have to bear his name for the ka to be able to inhabit the statue. The painted or listed victuals on the offering table on the wall were meant for the ka. By some magical means the deceased lying in the burial chamber also profited from the food via his ka.

Egyptian artists were also very familiar with magical practices, handed down from father to son. They played a large role in the manufacture of artworks. The completed statue was, just like the mummy, revived through the "opening of the mouth" ritual. Irtisen, an 11th-dynasty artist, boasted on a stele: "I know the secret of the divine words and the execution of the festival ceremonies. I have used every magic power without missing any of it, because I am truly an artist."

Ka Statue of Pharaoh Auibre Hor,
c. 1750 BCE
Wooden statue, height 170 cm (67 in.),
width 27 cm (10¾ in.),
length 105 cm (41¼ in.)
Cairo, Egyptian Museum

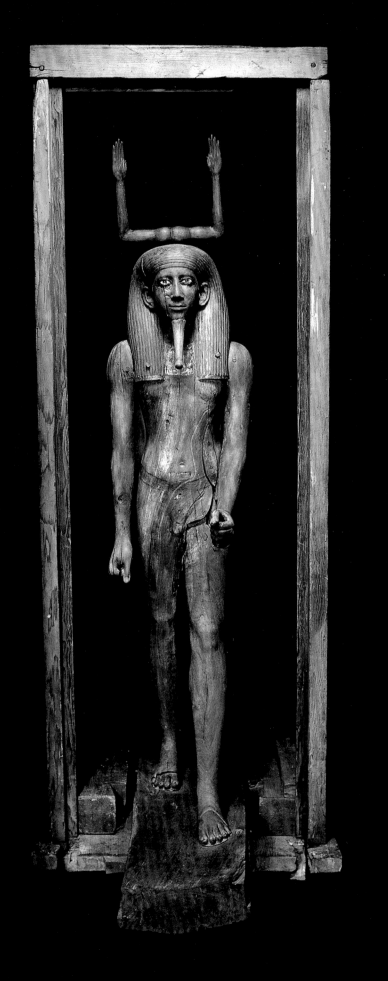

New Kingdom, 18th dynasty
Relief from the Sarcophagus of Queen Hatshepsut, 1479–1458 BCE

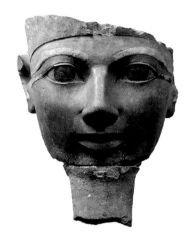

Head of Hatshepsut, New Kingdom, 18th dynasty, c. 1479–1458 BCE
Limestone, height 61 cm (24 in.)
Cairo, Egyptian Museum

The relief of a slim female figure decorates the long side of a sarcophagus made of red quartzite. It is supposed to keep the deceased in her "house of eternity". Her headdress identifies her as one of the most powerful deities of ancient Egypt. She is the Great Lady of Magic, the protector and mother goddess Isis. She is kneeling with elegant balance on the hieroglyph for gold, holding her hand over a ring, the symbol of eternity, and is wearing her emblem – a stylized throne – on her head. According to Egyptian mythology Isis searched for her murdered husband Osiris and posthumously conceived their son Horus from him. After that she buried and mourned for him.

The inscriptions surrounding the scene name the woman for whom the sarcophagus was meant: "King of Upper and Lower Egypt, Maat-Ka-Ra – daughter of Ra, Hatshepsut". It was found in a tomb in the Valley of the Kings near Thebes. If its axis is extended on an imaginary line through the mountains it exactly crosses Hatshepsut's huge mortuary temple, the "temple for millions of years", in the desert valley of Deir el-Bahri. However, the ruler who commissioned this tomb never moved into it. It was empty, there was no mummy in the heavy red sarcophagus, and the inner human-shaped coffins were also missing. Not until 2007 were Egyptologists, using new scientific methods, able to identify a hitherto anonymous mummy as that of Hatshepsut. For a long time not even the name "Hatshepsut" was known, even though this exceptional woman ruled Egypt like a man, as a pharaoh, for some 20 years. She was only rediscovered as a historic personality by the Prussian Egyptologist Karl Richard Lepsius in the 19th century.

Hatshepsut was the only "legitimate" child of the 18th-dynasty warmongering pharaoh Thutmose I and his great royal consort. However, Egyptian tradition excluded women from the hereditary succession and as was customary at the time, Hatshepsut was married to a half-brother, who ascended the throne as Thutmose II. When he died the throne went to his under-age son Thutmose III from a concubine, because Hatshepsut had only born him a daughter. Hatshepsut was to take over the regency for this nephew, but instead of keeping in the background like other female Egyptian regents and abdicating after her charge reached maturity, she had herself proclaimed ruler with the help of the priests. From then on she had herself represented with a naked male upper body, a royal beard, and a loin cloth. Instead of waging wars with Egypt's neighbours like her predecessors, she brought peace and rebuilt the drained country. However, when enemies appeared on the border in 1457 BCE and an army commander was needed, her nephew Thutmose III, who was for a long time only the co-regent, took over sole power.

Hatshepsut disappeared. Her successor had her name erased from steles and temples, her traits hacked out, and her statues destroyed or renamed. He probably did not do this out of hatred for her, but because a female pharaoh did not correspond to the Egyptians' "correct" world order. However, during her long reign Hatshepsut had a stylistic influence. The sculptors of her kingdom used her ruler-countenance as a model. Most of the statues of that period look like her: a pointy face, slightly curved lips, and almond eyes. The delicate profile of the goddess Isis protecting the empty sarcophagus also immortalized the traits of a ruler doomed to oblivion.

Relief from the Sarcophagus of Queen Hatshepsut, 1479–1458 BCE
Quartzite, height 86.5 cm (34 in.),
width 87.5 cm (34½ in.),
length 245 cm (96½ in.)
Cairo, Egyptian Museum, found in Thebes, Valley of the Kings

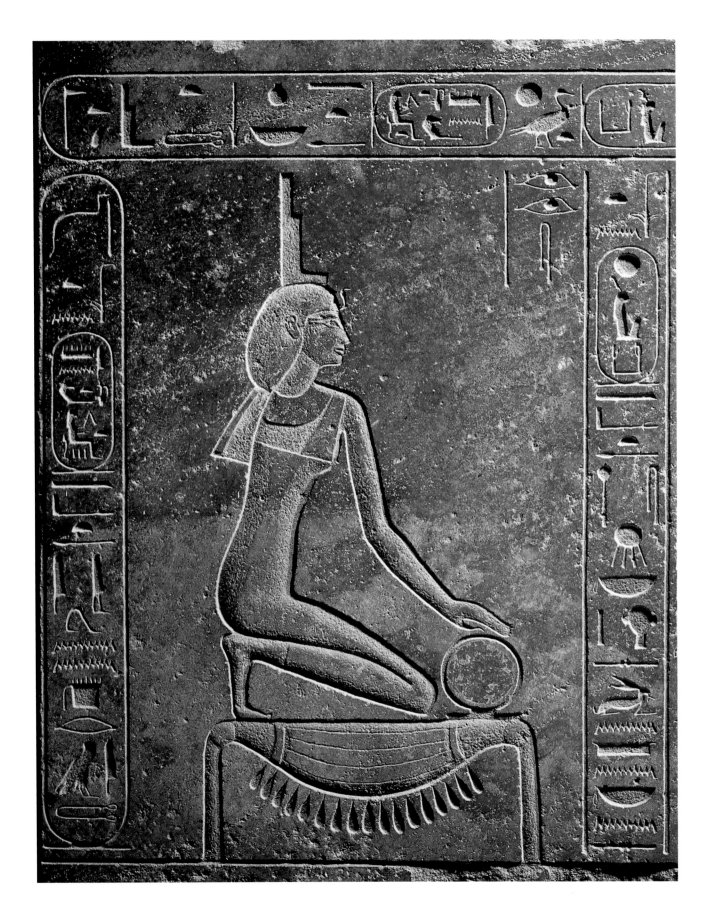

New Kingdom, 18th dynasty
Senemut and Neferure, 1478–1459 BCE

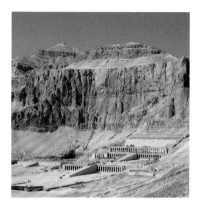

Queen Hatshepsut's Mortuary Temple,
New Kingdom, 18th dynasty,
c. 1479–1458 BCE
Deir el-Bahri near Thebes

It is a statue of a man squatting, his body wrapped completely in a long cloak. His body has taken on the shape of a square block, a cube: it is a cube statue. This type of statue, invented during the Middle Kingdom for private citizens, remained popular throughout the New Kingdom and particularly during the Late Period.

The cube statue is the most original and the most "Egyptian" statue form. It can be interpreted as an artistic embodiment of the hope of reincarnation: like a womb, the stone block houses the deceased squatting in a foetal position, while he waits in this pupated state for the rising of the sun. If he is hit by the sun's rays or his name is called out he will be able to rise from the burial mound and "stride out into the day".

Only very high-standing private individuals had the privilege of being allowed to erect a statue of themselves in a temple. The surface of a cube statue had a lot of surface area. This area could then be used to document for posterity one's personal biography and titles. Thus we can read on the block-like figure of Senemut in the Egyptian Museum in Cairo that he was the high steward of the god Amun and the high steward of the king. By the end of his career Senemut had acquired around 70 official and honorary titles.

Senemut's cube statue shows the damaged, roundish, smooth face of a middle-aged man with large ears. His eyes are wide open, his eyebrows protrude, and his mouth is small and fleshy. Senemut, who was of low birth, made his career in the military and in the royal treasury administration. He became a favourite and probably also the lover of Queen Hatshepsut, the woman who ruled as pharaoh for approximately 20 years. Maybe he assisted her rise to power. As chief royal architect Senemut planned and organized his mistress's huge building projects. "Senemut came to start off work on the great obelisks of millions of years," reads an inscription in the rock in the granite quarries of Aswan. It was he who designed the public symbols of the queen's power, shaped the art of her reign, and erected her still impressive, huge mortuary temple in Deir el-Bahri.

Hatshepsut made Senemut the tutor of her only daughter, the princess Neferure. This office is also documented on his cube statue. Neferure is sitting on his lap, completely enveloped in his wide cloak, from which only her head emerges. Like all Egyptian children she is wearing a single longish curl. The royal Egyptian cobra on her forehead attests to her position as heir to the throne. However, she probably already died in the eleventh year of her mother's reign. Senemut either fell into disfavour with Queen Hatshepsut during the sixteenth year of her reign or else he died around that time. We only know the year of his death as it was recorded on wine jugs in his tomb. Like Hatshepsut he also fell victim to the "damnatio memoriae" – the removal from memory: his name was erased and his statues were destroyed so that he would not be able to see, taste, or smell. Senemut had around twenty of his statues, seven of which showed him with Neferure, erected in the temples of Thebes. At hidden locations in his mistress's mortuary temple he had reliefs made of himself and below her temple complex he built a second, secret grave. Its ceiling was decorated with a magnificent starry sky. Only after several millennia had passed did Egyptologists rediscover his existence together with that of Queen Hatshepsut.

Senemut and Neferure, 1478–1459 BCE
Grey granite, height 130 cm (51¼ in.)
Cairo, Egyptian Museum

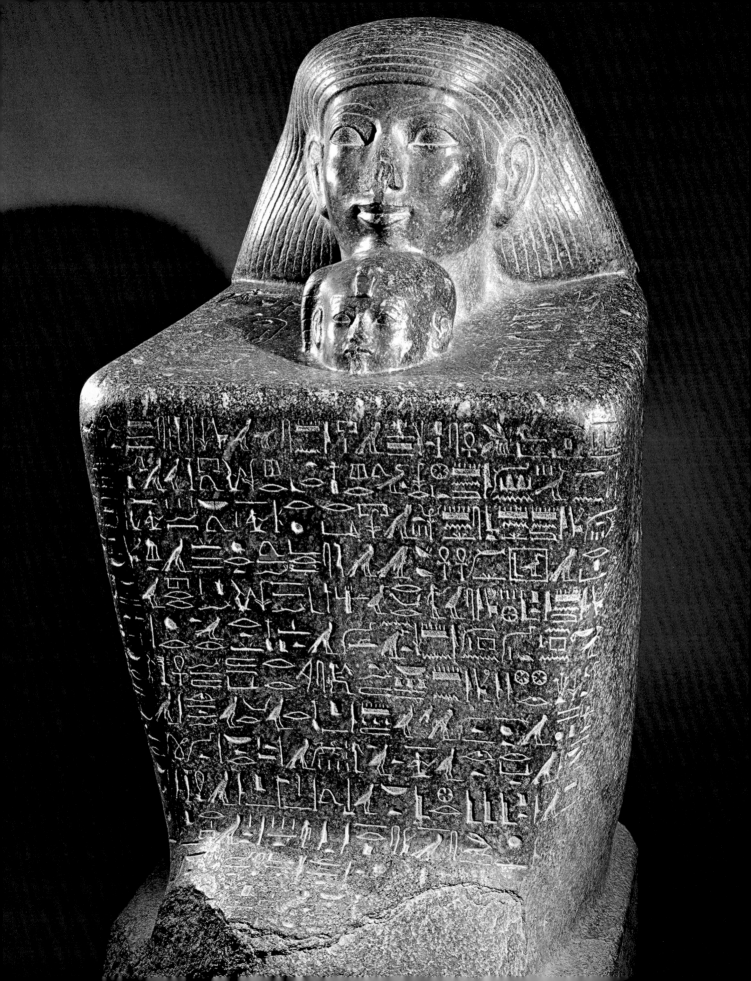

New Kingdom, 18th dynasty
Pharaoh Thutmose III Slays the Enemies, c. 1450 BCE

Thutmose III came to the throne on his father's death in 1497 BCE, but he was too young for the office. His aunt Hatshepsut took over the government and made herself pharaoh. She held on to power for a good 20 years and then vanished from the annals. Presumably she died.

Hatshepsut had focused her energies on the internal reorganization of the kingdom. What was required of Thutmose III was military campaigns. In Syria he had to re-establish Egyptian control and in Nubia he pushed back the border all the way to the fourth cataract. Under him the Egyptian kingdom reached its greatest expansion. Like most pharaohs he thanked the gods by building generous extensions to the temple complex in Karnak. This expression of gratitude was always also an expression of power, including the power to extinguish the memory of a disagreeable predecessor.

The name and image of Hatshepsut were removed in many locations. Thutmose III made the obelisk she had had erected in Karnak invisible by building a wall around it. Smaller displays of power on the temple walls were lists of conquered towns and countries or also, almost textbook-like, depictions of those plants and animals Thutmose III had brought home from his military campaigns in Syria. All the demonstrations of victory and power were dominated by the monumental relief on pylon VII, showing the king holding his enemies by their scalps.

The victorious pharaoh is amongst the oldest motifs of Egyptian art, but only over the centuries did it reach the standardized figuration that was also used in the wall at Karnak. It includes the body of the pharaoh leaning forwards, the long step forwards, the right arm (here missing) with the war club swinging high, and the outstretched left hand with the staff of command and the hair of the captives, who are conspicuously smaller than the pharaoh. The schematically lined up arms and soles of the feet symbolize an extremely large, almost uncountable number. They are kneeling, their arms raised in supplication. They are wearing the pointed beards that were not customary in Egypt. Some of them have their heads turned towards the beholder. This last factor was a calculated breach of the rules. The canon demanded a face to be portrayed in profile. Showing it from the front, which must have seemed immodest to the Egyptians, demonstrates the humiliation and the deep confusion of the men at the mercy of the pharaoh.

The relief on the temple wall does not portray a particular historical event. Egypt's defence was a perpetual responsibility. For that reason its portrayal avoided anything contingent and any referral to current events. There is an almost mathematical clarity. The arms are perpendicular to the imaginary line running from the heels to the top of the head. The staff is placed vertically. Just as the body demonstrates movement, the staff symbolizes stability.

When artists made sculptures of athletes in ancient times they always captured the moment when movement was reversed, that moment that made the entire motion sequence comprehensible. The same can be said about the man storming forwards while swinging the club. He symbolizes motion, but at the same time also calm and order. He unites strength and dignity and seems far removed from vicious slaughter. The captives resemble sacrificial animals intended to be offered to a god.

Pharaoh Thutmose III
Slays the Enemies, c. 1450 BCE
Part of a relief at the temple of Karnak

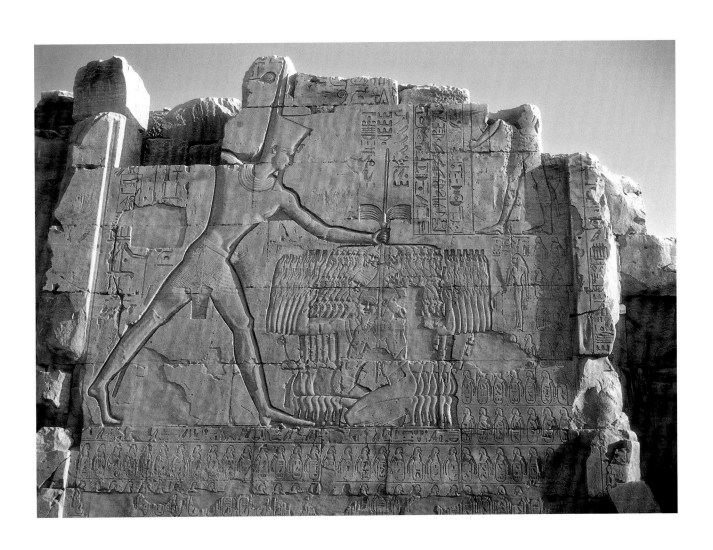

New Kingdom, 18th dynasty
Servants at a Banquet, before 1428 BCE

The body of the taller girl in the tight pink dress is shown from behind: this is extremely rare, possibly even unique in Egyptian art. It speaks of an incipient change in style during the transitional period from Pharaoh Thutmose III to Amenhotep II. The stricter, more ordered form of representation under Thutmose III made way for an art that exudes grace and charm through new elements and a relaxed style. Black lines mark the contours of the tall, slim figures that are silhouetted against the grey-blue background. The fiercely contrasting base colours were softened and the nuances became richer towards the end of Thutmose III's reign.

The scene is a detail of a mural in the extensive tomb of Rekhmire, the governor of Thebes. Rekhmire was also a vizier under Thutmose III, who, like his predecessors Thutmose II and Hatshepsut, brought rich spoils of war and tributes from Egypt's vassals to his capital of Thebes from military campaigns and expeditions. Thus the murals in the grave of Rekhmire tell stories about his duties as a vizier who, in the name of his king, received foreign envoys and the gifts sent by their countries. The biographical representations also show his investiture, the burial ceremonies after his death, and a large banquet. There, elegant ladies are sitting on papyrus mats and being served by standing, dark-skinned girls. It was servants, maybe slaves, who adorned their mistresses with jewellery before a celebration and brought them flowers, fruit, or perfume.

The girl in pink, whose face is half covered by strands of hair, is pouring a drink into a bowl from a small bottle. A larger container is standing on the ground next to her. The other servant girl is holding a tray of food. During the banquet fragrant ointments were placed on the heads and perfumed essences were effused. Fragrant oils, perfumed salves, and greases for skin and hair were a basic need in the dry desert climate. The Egyptians were considered to be experts in conserving them and producing ingenious mixtures. The most popular perfumes had names such as "ceremonial scent", "Syrian balm", or also "best Libyan cedar oil". These mixtures were not just used during the daily hygiene routine, they also played a large role during festivities. They even had their own god, the "lord of the nose". Perfumes were among the joys of life that ancient Egyptians did not want to do without in the afterlife either.

The sight of female beauty was also one of the joys of life. This is demonstrated not just by the many representations of women and young girls in the tombs, but also by Egyptian fairy tales: "Bring to me twenty women with beautiful limbs, deep breasts, braided hair, and whose bodies have not been stretched in childbirth," said King Sneferu, preparing for a boat trip to wile away melancholy and boredom. "Then they rowed heading north, then south. Then His Majesty's heart was happy at seeing the way that they rowed." They were not completely naked. According to one interpretation of the Old Kingdom text they wore nets of beads instead of dresses – an ingenious and seductive way of covering up. The pastel-coloured ankle-length dresses of the servant girls in the detail here are also diaphanous. They allow a belt to be seen through them, they are tight-fitting, and emphasize the curves of the young bodies. Particularly the tall slave in pink is so attractive and painted with so much love that everyone in the afterlife would like to be served by her.

Servants at a Banquet,
before 1428 BCE
Detail of a wall painting,
tempera on stucco
Thebes, West Bank,
tomb of Rekhmire (TT 100)

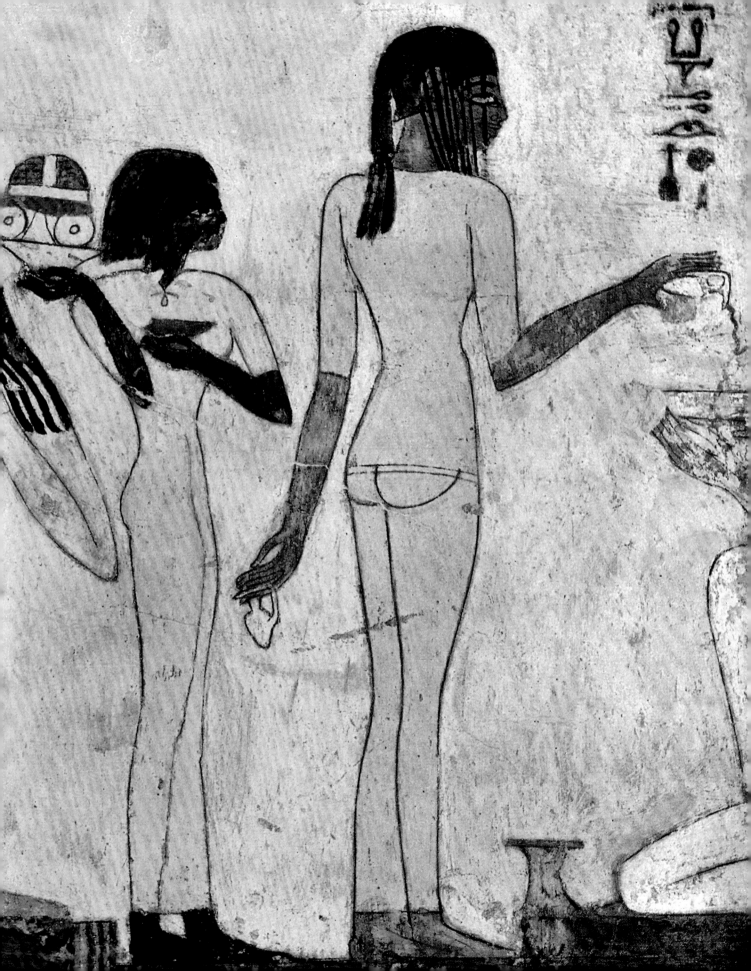

New Kingdom, 18th dynasty
Three Girl Musicians, c. 1395 BCE

One of the smallest but most beautiful tombs in the necropolis on Thebes' West Bank belonged to Nakht. He was only a petty official, a "priest of the hours" of the god Amun and temple astronomer. For that reason his "house of eternity" is located at mid-height on the slope of Sheikh Abd el-Qurna, where other simple officials had their graves.

The rock tomb dates from the end of Amenhotep II's reign and the beginning of that of Thutmose IV, a magnificent time for Egyptian painting. The scenes decorating the walls show amongst other things a grape harvest and Nakht hunting birds in a papyrus thicket. A banquet is portrayed on the left-hand, severely damaged back wall. A blind harpist is performing, Nakht's son is making an offering to his deceased parents, and behind him three girl musicians are playing their instruments. We know from text collections what they sang in this world: they entertained the guests at banquets with "Songs of the Orchard" or "Songs of the Meadow".

The two musicians in long white gowns on the left and right are playing the flute and the harp. The girl in the middle is naked except for a belt. She is holding a long-necked lute, a small instrument usually used by dancers. She also has the characteristically strong thighs and supple body of a professional dancer. In order to demonstrate her flexibility the painter went against the traditional rule stating that all people should look in the same direction. She is gracefully turning to the girl behind her, her plaits and strands of hair apparently flying to the rhythm of the music. The expressive hands of the harpists paint arabesques on the large instruments and the musicians' upper bodies overlap. Their dramatic performance for once does not maintain the dignity and composure required in Egyptian tombs. The traditional representational rules have been weakened in order to depict the heat and movement of the music and the dancing.

The painter has however carefully composed the scene with clever curves and diagonals. He also managed to combine it with the other scenes in such a way that the wall design does not fall apart into individual images. There is a uniform style throughout – perhaps this grave is one of the few Theban tombs where all the paintings were created by a single artist? By changing the paint blends the artist achieved bright and fresh colours on a soft, blue-grey background. A fine red-brown line emphasizes the figures' contours. The artist did however attempt to protect his work with a glaze. This glaze is slowly fading, suffering from a brown or yellow discoloration, and it is also causing the pigments to flake off.

Maybe people will soon only be able to admire the group on copies in the Metropolitan Museum of Art in New York, as even though they are protected by several layers of glass, the paintings suffer in the increased humidity caused by visitors. The English Egyptologist Norman de Garis Davies and his wife Nina copied the pictures from Nakht's tomb using the tempera technique in 1889, shortly after the tomb had been discovered. They alone allow us to get an impression of the original splendour of the colours. A blind harpist on the wall of Nakht's tomb not far from the three female musicians also warns with his song of the transience of things, not just that of paintings. This song was written down in other tombs:

> "…let thy days be happy and rest not therein.
> For no man carrieth his goods away with him
> O, no man returneth again who is gone thither."

Three Girl Musicians, c. 1395 BCE
Detail of a wall painting,
tempera on stucco
Thebes, West Bank, tomb of Nakht (TT 52)

Young, almost naked girls entertained the guests at banquets with dancing or music played on flutes, harps and lutes.

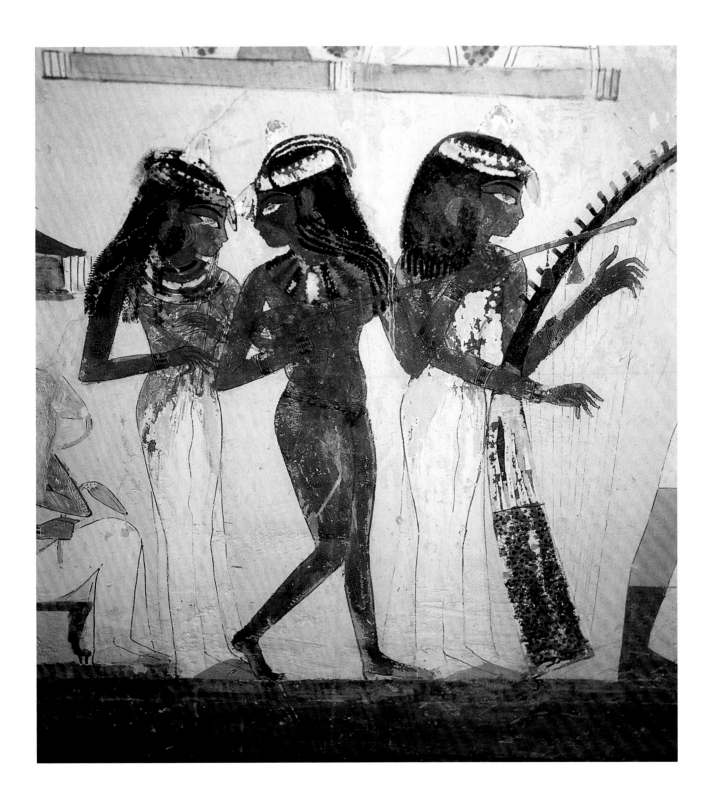

New Kingdom, 18th dynasty
Seated Figure of the Goddess Sekhmet, c. 1370 BCE

Cat Statue of Bast (Cat Goddess),
Late period, after 600 BCE
Bronze, 53.5 x 13 x 32 cm (21 x 5 x 12½ in.)
Berlin, Ägyptisches Museum

Sekhmet was the goddess of war. She was worshipped as the "powerful one", "rich in magic". Today her majestic over-life-sized image can be seen in many museums. She is depicted with a slim, female body and the head of a lion with a long mane. The solar disc above identifies her as the daughter of the sun god Ra. In her left hand she is holding the life-giving ankh.

The Sekhmet statue in Berlin shows the remains of an Egyptian cobra on her forehead. This cobra was the protector of the pharaoh and symbolized royal power. Because of its strength and courage, the Egyptians already considered the lion to be the king of the animals. Lions accompanied the pharaohs through the millennia. A whole lion family was buried close to the grave complex of pharaoh Hor-Aha, the founder of the 1st Egyptian dynasty. Towards the end of the New Kingdom Ramesses II and Ramesses III commissioned temple reliefs that showed them riding into battle on their chariots, accompanied by lions. Finds of bones revealed that they kept lions in their palaces. Hunting lions in the Nubian desert was a royal privilege. It is likely that the sickly King Amenhotep III wanted to prove his physical ability when he had it documented on a hunting scarab – a commemorative and propaganda amulet – that he had slain 102 lions!

The goddess of war Sekhmet was called the "mother of Pharaoh" and was able to help to victory in battle. She annihilated Egypt's enemies, but she was just like the Egyptian cobra on the pharaoh's head: moody, wild, and dangerous. She was related to the lioness Pakhet, "she who tears", and brought not just victory, but also disease, pestilence, and death. One myth recounts that it was Sekhmet and not her sister Hathor who was once sent out as the "Eye of Ra" by her furious father to destroy the children of Ra, which could only be prevented by a trick.

The Egyptians also wanted their female goddesses to be motherly creatures providing protection and sustenance: lionesses were considered particularly caring. For that reason Sekhmet, like other goddesses too, was given a contradictory dual nature. She could be appeased by prayers and offerings and she could be moved to cure the plagues she had sent. As the "comely" one she relieved pain, protected from disease, and was responsible for medicine. Egyptian physicians who relied on magic healing called themselves the "Priesthood of the magical Sekhmet".

Under this positive, gentle aspect Sekhmet occasionally merged with the feline goddess Bast, whose name was written with the hieroglyph meaning "ointment jar". She had been worshipped in the town of Bubastis in the Nile delta since the Old Kingdom. Intent on continuity and harmony, the ancient Egyptians liked to unite their various deities. Sekhmet originally came from the old capital of Memphis, but when the royal residence was moved to Thebes during the New Kingdom, she was merged with the local goddess Mut. In Thebes she then received her most important site of worship in the Mut-complex right next to the great Temple of Amun in Karnak. There and in front of his mortuary temple in the west of the capital, Pharaoh Amenhotep III had more than 600 statues of the lion goddess erected. This was the same ruler who boasted of slaying 102 lions on a hunting expedition.

Examinations of his mummy have shown that he suffered from growths on his jaw. He probably hoped Sekhmet would relieve his pain. It is thanks to him that so many lion goddesses are protecting our museums today.

Seated Figure of the Goddess Sekhmet, c. 1370 BCE
Granite, height 189 cm (74½ in.)
Berlin, Ägyptisches Museum

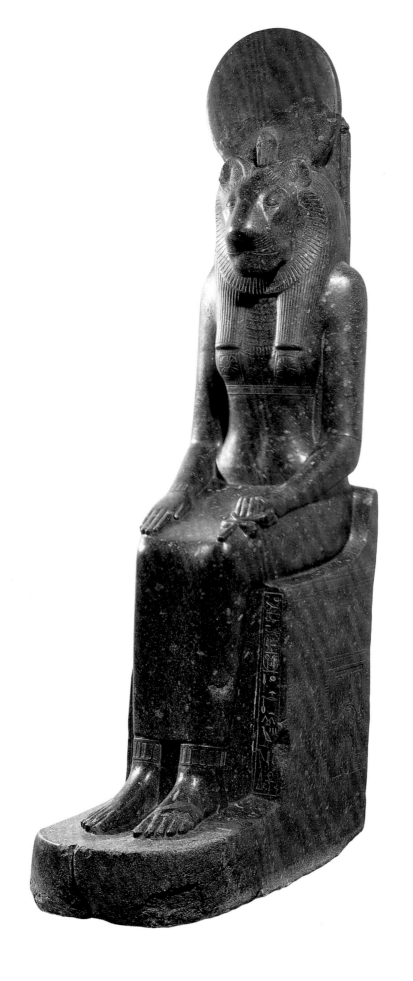

New Kingdom, 18th dynasty
Queen Tiye, c. 1360 BCE

The face looking at us here is not that of an ideal young beauty, but that of a mature woman with wrinkled skin tanned by the sun. Her eyes lie under heavy lids, the features are sharp. She has pulled down the corners of her mouth in contempt. It is the portrait of a wilful, self-confident person. She was called Tiye and more is known about her than about any of the other queens of the 18th dynasty, with the exception of Queen Hatshepsut. We even know less about the popular Queen Nefertiti. Tiye was the rightful Great Royal Wife of Amenhotep III, the pharaoh who ruled Egypt as "sun god" at the time of its greatest prosperity. He consorted with the rulers of Babylon and the Mitanni kingdom on the upper Euphrates. He also erected huge buildings in Thebes and Karnak. Against the rules he elevated a girl, Tiye, the daughter of an official who was not of noble birth, to become his queen. Amenhotep III announced this fact to his subjects on hundreds of inscribed scarabs – the popular Egyptian propaganda tool in the shape of a beetle. It may have been a love match…

Tiye was the first queen to play an important political and religious role while her husband was still alive. This also went against tradition. Tiye appears on many official monuments next to the king and is also represented as a sphinx, a motif that had previously been reserved for pharaohs and gods. In Nubia Amenhotep built a temple for her where she was worshipped as the goddess Hathor. There are also reports about Tiye's strong political influence right up to her death. Even while her husband was alive she was familiar with all the diplomatic events and must even have corresponded with foreign allies herself, because when her husband died after 38 years and her son Amenhotep IV (the later Akhenaten) ascended the throne, the Mitanni king Tushratta sent a letter to the new king stating: "Tiye, your mother, knows all the words I spoke with your father." Tiye outlived her husband by at least nine years. The yew wood head shown here was probably attached to a body made of a different material, and may have been altered during this period. When it was found the back of the head was covered by a bag-wig reaching down over the nape of the neck made of matted canvas. But traces and X-rays indicate that below the wig she is wearing a headscarf made of sheet silver. Two Egyptian cobras attached to the headdress are hanging down over her forehead. The replacement of the headscarf – a headdress reserved for pharaohs – by the wig was due to Tiye's change of status from royal wife to widow. One of the two round ears is now covered by the wig. Together with the wig she was also given a new headdress consisting of feathers, a solar disc, and cow horns. It was recently discovered in the storeroom of the Berlin Museum.

Tiye kept her influence when she became a royal mother. She is said to have split her time living in Al Fayyum and the new residence in Amarna. A relief in a tomb shows Tiye attending a family dinner with her son Akhenaten, his wife, and their daughters. The unusually realistic traits of the ebony portrait head on display in Berlin may show the first hints of the stylistic changes with which Akhenaten was to revolutionize Egyptian art for a short period. Fragments from a sarcophagus bearing Tiye's name were found in the royal tomb at Amarna; a mummy attributed to her is on display in Cairo.

Queen Tiye, c. 1360 BCE
Head of yew wood, silver, gold and glass, height 9.5 cm (3¾ in.)
Berlin, Ägyptisches Museum

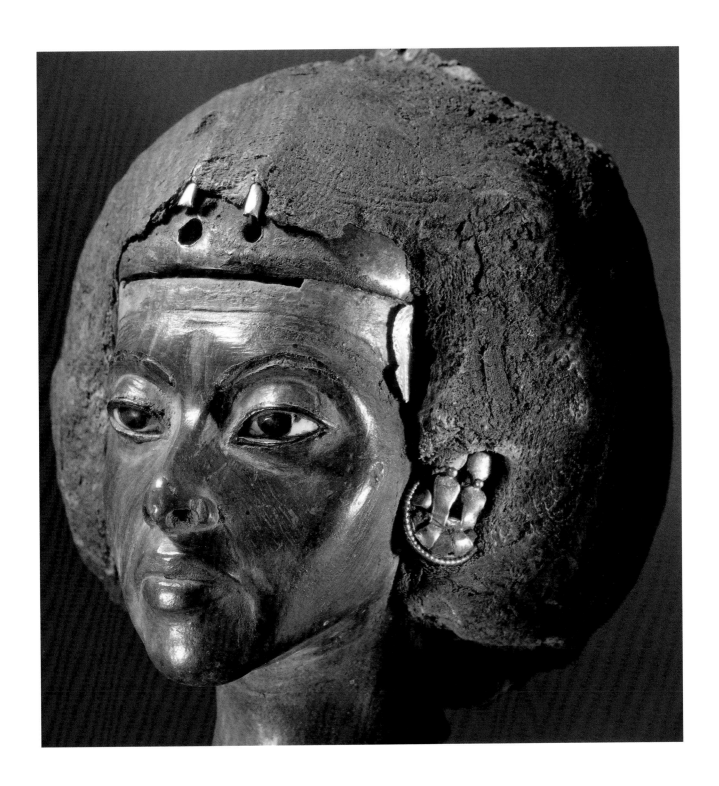

New Kingdom, 18th dynasty
Hunting Scene in Papyrus Thickets, before 1350 BCE

A painted biotope with water, plants, and animals once decorated Nebamun's rock tomb, located in a bare desert landscape. There, in the necropolis of the West Bank, across the Nile from Thebes, 18th-dynasty officials had their grave complexes built and their cult chambers richly decorated. The scenes of festivals, banquets, and trips painted on the walls reflect their luxurious everyday lives. Nebamun was "a scribe who counts the grain in the granary of divine offerings". The fragment that was removed from the wall and is now on display in London shows the tomb's owner Nebamun participating in a sport – hunting birds with a throwing-stick – that was reserved for high-ranking people. "With strong arms and a big stride" – the Egyptian ideal of a dynamic-active man – Nebamun is standing firmly on a fragile raft made of bundled papyrus. Fish are swimming in the water below the raft. A pale ginger cat is participating in the hunt in the thicket. In its mouth and its paws it has its flittering catch. In his one hand Nebamun is holding a throwing-stick, with the other he is releasing a couple of decoy birds.

A papyrus bush with red blossoms contains a nest with eggs. Above it fly a swarm of hunted birds. Their feathers are shown in great detail. The black-grey-blue shading that gets lighter and lighter towards the top achieves an almost impressionistic effect. The artist or artists who worked on this decoration were masters of their craft. They kept to the traditional rules of the Old Kingdom in Nebamun's painting. The tomb's owner appears in hierarchical austerity and corresponding to his rank he is shown on a larger scale than his wife and daughter. He is wearing a short loin cloth and a decorative collar for the hunt. On top of his wife's heavy wig is a scented ointment cone. She is holding a lotus wreath in her arms and seems to be primed for fun: excursions into reedbeds were considered amusing by the Egyptians.

Anything bringing the Egyptians out into the wilderness of the lakes and marshes, be it boating games, fishing, hunting, or picking papyrus and lotus flowers for bouquets was considered a "feast for the eyes" and an "exhilaration" by the Egyptians. The rowing trips that could be taken in the vicinity of Heliopolis and Memphis were praised in love songs and in a fairy tale a melancholy ruler is advised to take a trip: "The heart… will rejoice… when you behold the beautiful birds' nests of your lake and the surrounding fields and lovely shores." Women taking trips into nature were charged with eroticism: the king did not go on the trip by himself. He took the "twenty most beautiful women of his palace" with him. A poem praises the "bird-stalking lover"; hunting in reed thickets was a metaphor for love and sex that was popular in Egyptian tombs, where a realistic representation of sexuality was forbidden.

However, the moist papyrus thicket contained even more symbolism for the beholder: this was where the divine Horus, the son of the dead Osiris, had been raised in secret. Thus it was considered a religious, mythical site of fertility and regeneration. Even posthumous procreation seemed possible there – Osiris had fertilized Isis after his death – a comforting promise for the deceased in his grave. In addition each hunting scene also recalled the mythical fight between Horus and his enemy Set and promised the happy resolution of chaotic forces that constantly threatened the world order.

Hunting Scene in Papyrus Thickets,
before 1350 BCE
Fragment of a wall painting in the tomb of Nebamun, tempera on stucco, height 81 cm (32 in.)
London, The British Museum

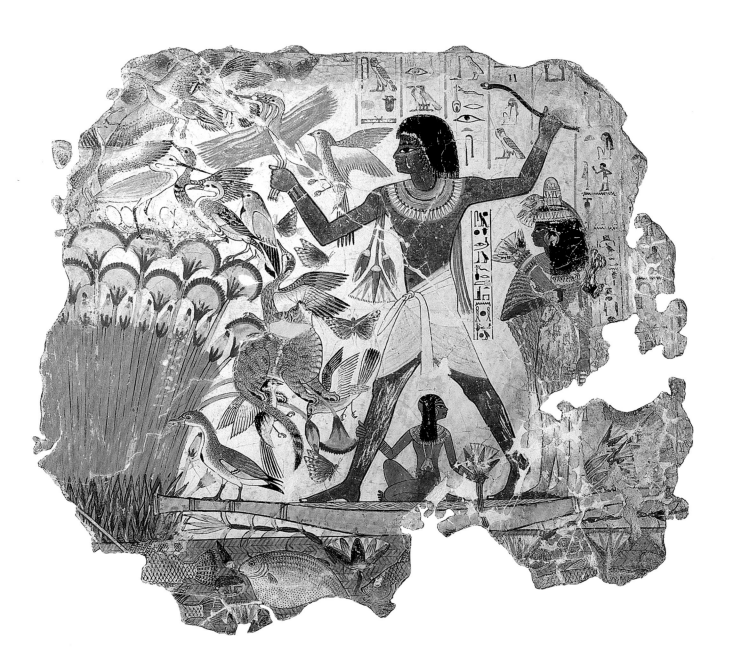

New Kingdom, 18th dynasty
Husband and Wife at a Banquet,
c. 1350 BCE

In her free right hand the young woman is holding a lotus blossom, with her left hand she is embracing her husband. Her hand is on his left shoulder. This is how Egyptian marital couples had been represented since the Old Kingdom – discreet and demure, as befitted grave pictures designed for eternity. The form of representation follows the old canon: face in profile, shoulders from the front. The lady's left arm has been lengthened without heed to anatomical reality.

This relief finely carved into limestone was created in a period of prosperity and stability under Pharaoh Amenhotep III. It observes the traditional rules, shows a balance of the volumes, and harmonious proportions and lines. It has been worked with great virtuosity: it is a culmination, a high point of classical Egyptian art. The next pharaoh went down a radically different path in this area and under his successors the old perfection was rarely achieved.

The portrayed couple, May and his wife Urnure, belonged to the ruling class; both are shown in gossamer, highly-pleated gowns with ingeniously worked wigs. In the afterlife the man, as one of the highest officials at the royal court (Master of the King's Horses), is wearing a double row of gold collars around his neck and he is holding a sceptre of dignity. His wife with the lotus blossom above her forehead was lady-in-waiting to the queen and was also a priestess of Mut.

This noble couple are sitting at the table in perfect beauty together with the other guests and relatives invited to the banquet by the tomb's owner. They are participating in a ritual meal in honour of Ramose, a "feast in the house of blessedness, built in the City of the Dead". The Egyptians loved conviviality in life. They liked to serve plenty of food, and to drink heavily. Thus they did not forget their motto in the grave either: "Delight the heart, exult in joy, participate in good things, a lotus blossom at the nose and myrrh as an ointment on the head."

The tomb's owner Ramose was a high official, governor of Thebes, and vizier under Pharaoh Amenhotep III during the last years of his reign. He also served under his successor Amenhotep IV (Akhenaten) during the first years of his reign. As befitted his high rank, Ramose's grave complex in the necropolis on Thebes' West Bank is large, with a big hall of columns, decorated by the best artists of the time. On the wall next to the entrance, reliefs depict the feast as well as the tomb's owner making sacrifices. Another wall displays the magnificent burial of Ramose in great detail, though not as a relief but as a painting. The relief of the feast is missing its colours. Only the almond eyes of the guests are contoured in black, made-up as they were in life.

The plan was probably to decorate the entire grave with painted reliefs, but it is likely that this was abandoned prematurely. Usually work was stopped immediately after the person commissioning the work had died. Perhaps Ramose just died too early. However, it is even more likely that the grave in Thebes remained unfinished because the vizier Ramose followed his young king Amenhotep IV, who called himself Akhenaten after he took the throne, transferred his court to Amarna, and broke with many traditions. The guests at the table of the unfinished Theban grave of Ramose are still celebrating their never-ending feast in the old style, but in the back part of the tomb it is no longer the old gods that are being worshipped, but the sun alone that Akhenaten put in their stead.

Husband and Wife at a Banquet,
c. 1350 BCE
Detail of a relief
Necropolis on Thebes' West Bank,
tomb of Ramose (TT 55)

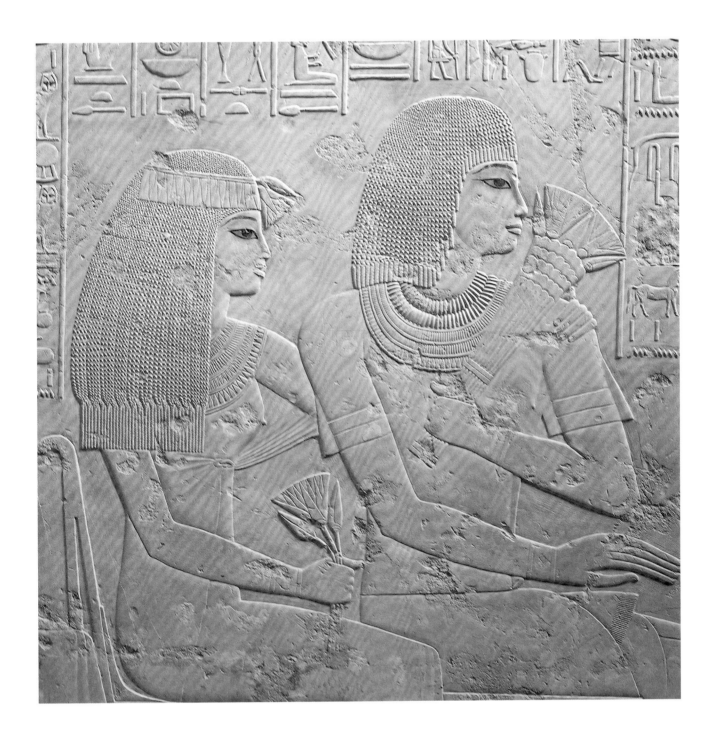

New Kingdom, 18th dynasty
Female Mourners, c. 1350 BCE

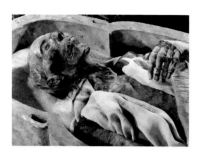

Mummy of Pharaoh Ramesses II,
New Kingdom, 19th dynasty, c. 1213 BCE
Cairo, Egyptian Museum

Wailing women were part of every proper Egyptian burial. They mourned the deceased and tried to wake him from death's sleep with loud screaming. The hair is dishevelled and the breasts are naked over gowns rubbed in blue-grey ash. Tears run down their faces. The raised arms are a traditional way to symbolize mourning and despair. The artist composed them as a compact group with parallel bodies. The heads are arranged on three levels. He has managed to avoid monotony by making small variations: a line of close-standing figures in profile, one of them looking back, and a naked adolescent girl: the scene is painted on a white background and the artist did not use much colour throughout. The gowns are light blue, the hair is black, and the faces are pale yellow.

These wailing women are part of a funeral procession that decorates one of the walls in the tomb of Ramose, a vizier under Pharaoh Amenhotep III. Although his grave complex is elaborately decorated it remained unfinished. An unpainted relief portrays a feast; the burial ceremonies were only painted. They make up a detailed frieze that covers several bays on the south wall: on the right the mourning women await the procession bearing the deceased. They appeared in groups that were bigger or smaller depending on the rank of the person being buried. Mourners were not cheap. They were more expensive than the sweets, breads, floral wreaths, and scent cones also required by the ritual. This is proved by a detailed burial bill dating from the second century CE. The most expensive items by far were the strips of linen the mummy was wrapped in, as well as the preservative oils and resins.

While wailing women are mourning on the right (this function was apparently also done by men for a short time), the left side of the wall in Ramose's tomb shows a long, painted procession. It leads from the embalming site by the Nile, where the deceased was mummified, across the fertile land to the Theban necropolis. There, where the sun goes down, the goddess of the West, "she who loves silence", was said to live on a peak shaped like a pyramid.

The wall painting shows the transport of the mummy in an open, magnificently decorated sledge, drawn by oxen. Mourning relatives and colleagues accompany the deceased. Priests walk at the head of the procession. They will perform sacrifices, offerings, transfiguration rituals, and especially the magical "opening of the mouth" ceremony for the deceased's revival. Numerous servants are carrying floral wreaths, fans, filled jugs and boxes, chairs, benches, everything to ensure not only a wealthy Egyptian's survival in the hereafter, but also that he would not want for anything once there.

Those who could afford it spent their entire lives preparing for an elaborate burial and obtaining the grave goods they would take with them in their sarcophagi or their burial chambers. "Return to Egypt," a pharaoh wrote to his subject Sinuhe who had left his native country, "Do not let death come upon you far away amongst the Asiatics… look forward to the day of your burial!" The pharaoh wooed Sinuhe with a beautiful Egyptian burial, one like the artists painted on the walls of Ramose's tomb: "A sledge drawn by oxen shall bring you to your tomb while the singers go in front and the dancers follow behind…"

Female Mourners, c. 1350 BCE
Detail of a wall painting,
tempera on stucco
Necropolis on Thebes' West Bank,
tomb of Ramose (TT 55)

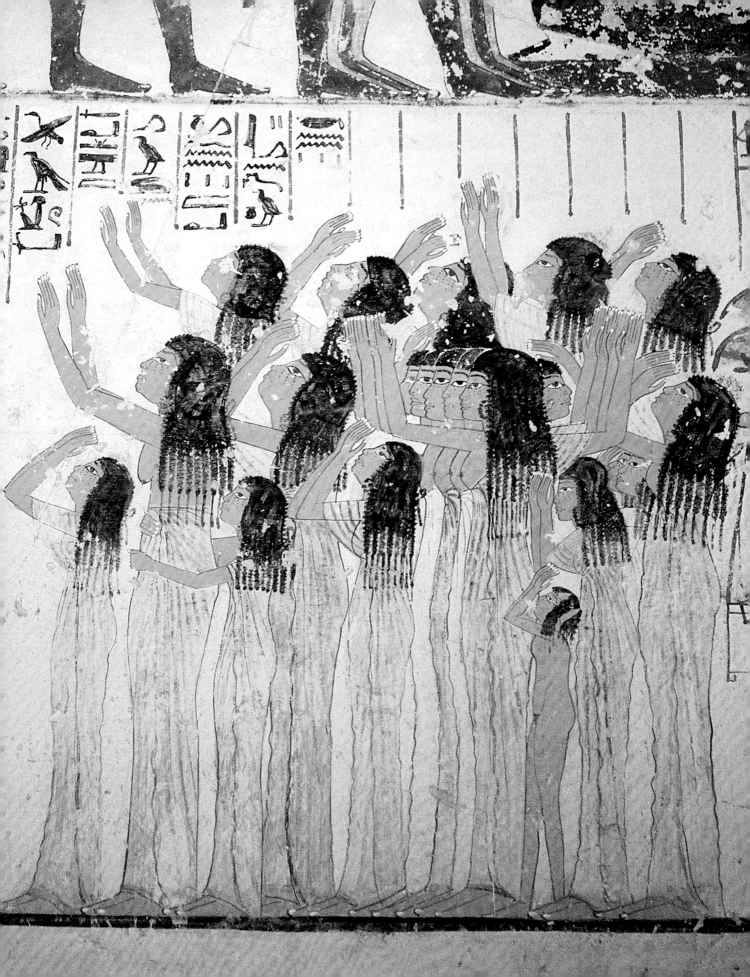

New Kingdom, 18th dynasty
Head of Amenhotep IV (Akhenaten), c. 1345 BCE

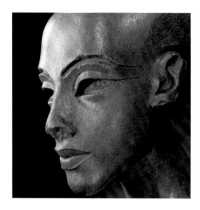

Head of a Daughter of Akhenaten,
New Kingdom, 18th dynasty, c. 1345 BCE
Quartzite, height 21.4 cm (8½ in.)
Berlin, Ägyptisches Museum,
from Tell el-Amarna

A new face in the line of Egyptian kings: Amenhotep IV, who called himself Akhenaten and ruled for 17 years, probably from 1350 to 1333 BCE. The eyes are narrower than the eyes in the portraits of his predecessors and his lips are fuller and curved to a greater extent. The face does not approach the usual square form, but rather resembles an acute-angled triangle ending in his extended chin. The heads of Egyptian rulers were always stylized to a certain standard – a new pattern emerged under Akhenaten, which was probably developed from the king's features.

This break with traditional representation was an expression and result of a politico-religious revolution. During their approximately 4,000-year history, the Egyptians worshipped many gods. Often they were only of regional significance and then merged with other deities, adapted, and altered their character. For a long time Ra was the original and highest god. When Thebes rose to become the centre of government the local god Amun was elevated to the status of national god. Amenhotep IV deposed him. He also denied all the other gods, except for the sun god Aten visible in the sky from dawn to dusk: "Ra, Hail, Aten, thou the lord of beams of light…"

Amenhotep IV turned Egyptian polytheism into a monotheistic religion. He replaced the many gods, often presented as beings that were half human and half animal, with the solar disc, a god who could really be seen in this world with people's own eyes. This one god, Ra in the guise of Aten, had just one son on Earth: Akhenaten. That is how it was written in an adoration and propaganda hymn. Akhenaten was the intermediary between humans and god. "And there is no other that knows thee… For thou hast made him well-versed with in thy plans and in thy strength." The king as the son of god was a traditional idea, but over the course of the New Kingdom the belief had grown that every Egyptian could communicate directly with his god or gods. Akhenaten did not permit this. He put himself between god and humans and thus indirectly strengthened his own position of power.

It is quite likely that this overthrow of the gods was not just religiously motivated, but also had solid political reasons. It could be that the priests of Amun, concentrated in Karnak, had become so influential that the pharaoh had to dismantle their power so that he could rule unhindered. The fact that Akhenaten moved the royal residence from Thebes to el-Amarna supports this speculation. In the first year of his reign he built a temple to his god Aten in Karnak, in the fifth year of his reign he changed his name from Amenhotep to Akhenaten ("pleasing to Aten"). In the sixth year he moved north to his new residence. He called it Akhet-Aten – "horizon of Aten". After the twelfth year of his reign the vigour with which Akhenaten pursued his reforms seemed to wane. Perhaps this was because he started having problems with the Hittites: they entered an Egyptian zone of influence in Syria. Egyptian correspondence with friendly tribal leaders in and around Syria was found in the archives of Akhet-Aten and is now considered to be an outstanding document of diplomatic effort from over 3,000 years ago. After Akhenaten's death the priests of Amun reinstated the old gods again. Tutankhamun, the next-but-one successor of the revolutionary, moved the royal residence back to Memphis.

Head of Amenhotep IV
(Akhenaten), c. 1345 BCE
Sandstone, height 64.5 cm (25½ in.)
Luxor, Museum of Ancient Egyptian Art

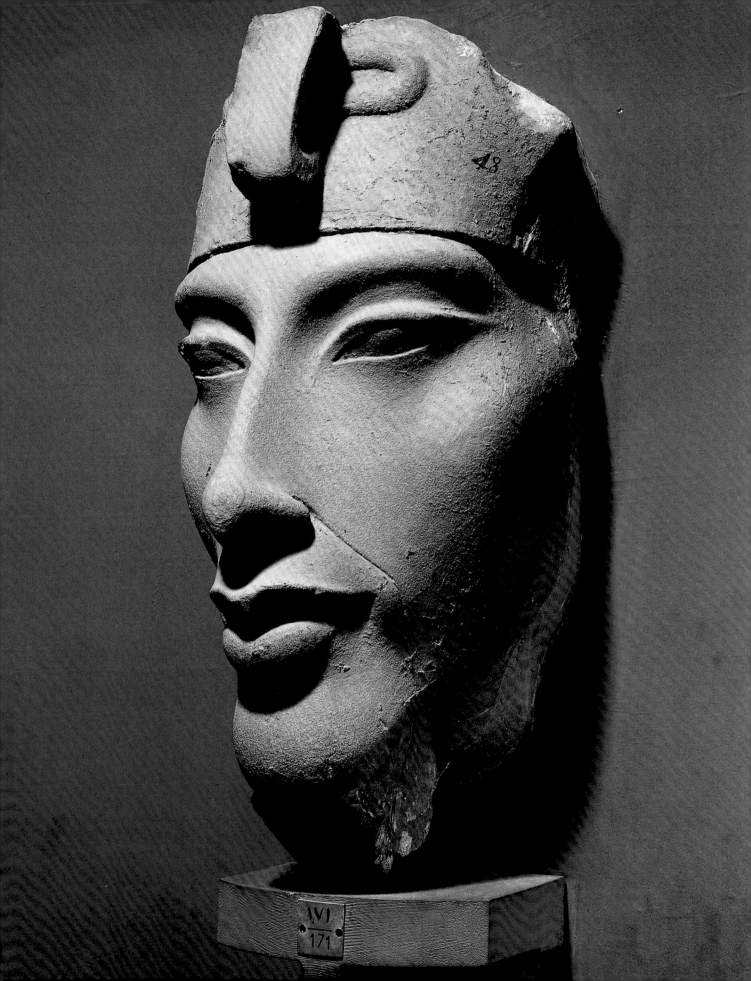

New Kingdom, 18th dynasty
Royal Family, c. 1345 BCE

EXCERPT FROM THE HYMN TO THE SUN
Thou appearest beautiful,
Thou living sun, lord of unending time!
Thou art sparkling, beautiful and strong,
love for you is great and powerful;
Thy rays, they touch every face
Thy radiant skin enlivens all hearts;
Thou hast filled the two lands with love for you.
Thou lofty god, who made himself,
Who created all lands and brought forth what is in them
To men, herds and wild beasts and
All the trees that grow on earth –
They live, when thou risest for them.
Thou art mother and father to them that thou hast created;
Their eyes – when thou risest, they see because of thee.
Thy rays have illuminated the whole land,
Every heart delights in thy appearance,
Thou hast appeared as their lord.

Akhenaten and Nefertiti are playing with their three daughters. The king appears to be kissing the oldest, Meritaten. Such intimate scenes of royal family life had neither existed prior to Akhenaten's reign nor did they occur again after it. They posed unfamiliar problems to sculptors. According to tradition even older children were shown smaller than their parents: it was not the real height that mattered, but the "scale of importance". Here the father is holding his adolescent daughter as if she were a toddler. Intimate contact and symbolic size-difference are difficult to bring together.

It was not only the look into royal private life that distinguished the Amarna period from Egyptian tradition, but also the body shape of the members of the royal family. The princesses are shown with abnormally protruding backs of the head. The girls and the royal couple all have extremely thin arms and long necks. The father's paunch is bursting over his loincloth. On other pictures and statues he is shown with femininely curved hips. The reasons for these deviations from the traditional human image are unclear. It is possible that Akhenaten's physical attributes were highly stylized, but it is also possible that the king also wanted to present a new image of the human being together with his new image of god. However, all of this is speculation.

Also new during the Amarna period were the sun rays that the slender hands of people and the earth reached out to. "Thy rays, they touch every face," says the Hymn to the Sun, "Thou art mother and father to them that thou hast created…" Some of the solar rays on the family relief are handing the royal couple the ankh, the symbol of "life". These solar rays can only be found on images with the pharaoh. They visually encapsulated Akhenaten's royal ideology: even though the sun god owns the entire world he wants direct contact only to Akhenaten, who is his son, and alone knows the divine plans. There is a good piece of power politics behind Akhenaten's ideology: he removed the priests' access to the highest authority and thus lessened their influence. This relief demonstrates two things: on the one hand it shows Akhenaten's theological power position, and on the other it shows his closeness to the populace by the insight into royal family life it provides. The limestone relief was probably part of a family altar in the royal residence.

Royal Family, c. 1345 BCE
Limestone relief, height 32.5 cm (12¾ in.),
width 39 cm (15¼ in.)
Berlin, Ägyptisches Museum

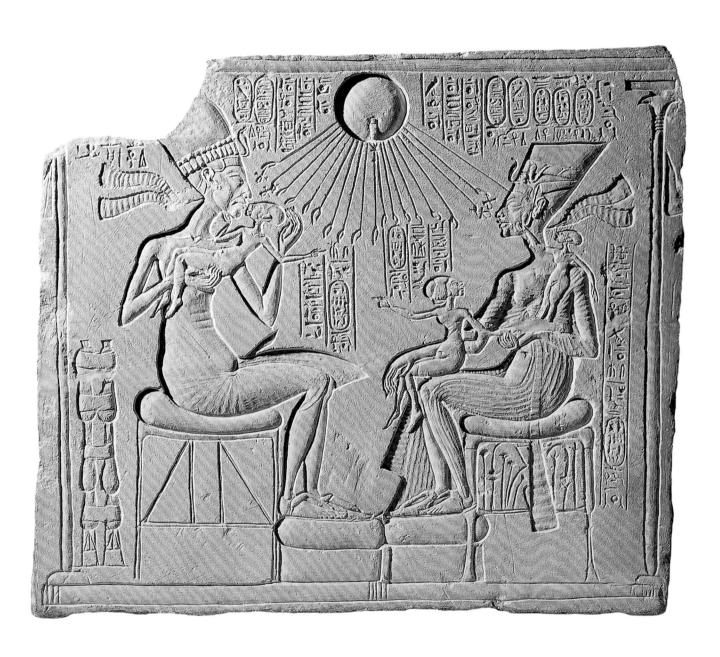

New Kingdom, 18th dynasty
Queen Nefertiti, c. 1340 BCE

Bust of Nefertiti, New Kingdom,
18th dynasty, c. 1350 BCE
Quarzite, height 18 cm (7 in.)
Cairo, Egyptian Museum

After Akhenaten's death – it is known neither how he died nor where he was buried –
it was first Smenkhkare, then Tutankhaten who ascended the throne. Tutankhaten had
married one of Akhenaten's daughters. He moved back to Memphis with his royal house-
hold. Thebes once again became Egypt's cultural-religious centre. The new king replaced
the "aten" in his name with "amun", thus showing he stood by the world of traditional
gods. He also reinstated the priests and gave them back their rights. Akhenaten's resi-
dence and the temples he had built were destroyed or dedicated to other deities, the
pictures and the king's name where chiselled out. Just as Akhenaten had launched an
iconoclastic campaign against the old gods, Amun's priests now persecuted him and Aten.
What has remained from the Amarna period are items such as the bust of Nefertiti that
have only survived by chance.

It was found in December 1912 by an excavation team of the Deutsche Orient-
Gesellschaft, financed by James Simon, a businessman and patron of the arts from Berlin.
Simon had received a licence from the Supreme Council of Antiquities (called the
Department of Antiquities at the time) to perform excavations in the surroundings of
Akhenaten's residence. The excavators came across the remains of a sculptor's work-
shop. Its master was a certain Thutmose. He is one of the few artists whose name has
come down to us. The workshop contained shards, sketches on clay, and study busts.
In January 1913, under the terms of the contract, a portion of the finds were made
over to Simon. He was allowed to export them. In the autumn of that same year he
made them over to the Royal Prussian Art Collection in Berlin. One of the items was
the bust of Nefertiti, which has since then been the most famous work of Egyptian
art, comparable in popularity to Leonardo da Vinci's *Mona Lisa* in the Louvre. The
bust of Nefertiti is not a finished work, but more of a study object intended to serve
as a model for further representations of the queen. That at least is the dominant
opinion, which can be supported by the fact that the pupil of the left eye is missing:
if the bust was a study object there would be no need to make both pupils. Could
it not however also be that the bust remained unfinished because the queen fell into
disfavour or died? She is not mentioned again after the twelfth year of Akhenaten's
reign, nor has any tomb been found.

Nefertiti is wearing a blue crown encircled by a ribbon. An erect Egyptian cobra
was once located at the light-coloured fracture site. She is also wearing a decorative
necklace, which – together with the crown – gives the bust a frame of colour at the top
and bottom. It gives a particularly pleasant appearance to the face's light brown flesh
tone. The face is made up: the eyelids were circled in coal dust and the lips were dyed
with ochre.

The queen's name means "the beauty that has come". Without a doubt it is the
striking beauty of the bust created over 3,000 years ago that still fascinates us today:
the slender neck, the curved mouth, the almond eyes, the wrinkle-free skin – the
sculptor Thutmose developed from the real queen (and mother of six) an ideal that is
still current today. However, this beauty ideal also had links with Egyptian tradition.
It seems paradoxical that this period, with its artistic deviations from the norm and
its monstrous backs of the heads of the princesses and the vertically elongated royal
heads, was also the period that gave us a work that became the epitome of Egyptian
and timeless beauty.

Queen Nefertiti, c. 1340 BCE
Limestone, height 50 cm (19¾ in.)
Berlin, Ägyptisches Museum

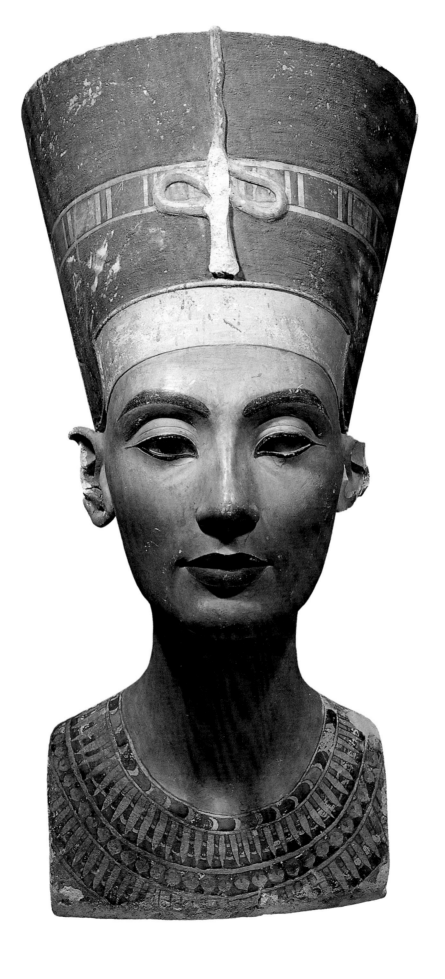

New Kingdom, 18th dynasty
Gold Mask of Tutankhamun, c. 1323 BCE

***The Valley of the Kings**, Thebes*

Tutankhamun was the successor-but-one of Akhenaten. He started the rehabilitation of the gods Akhenaten had denounced. He died in 1323 BCE at 18 or 19 years of age; a computer tomogram of his mummy suggests he died in a riding accident. He ruled for ten years and historically was of no great significance. The reason for his incredible popularity during the 20th century CE was the discovery of his tomb. Tutankhamun's rock tomb had been opened by grave robbers shortly after his burial, but only a few items had been removed. It was then sealed by the site guards in the Valley of the Kings and later covered by the excavated rubble from another grave. Most of the treasures the young king was given upon his death remained with him in his grave.

When the tomb was found the mummified body was encased eight times: first came four shrines of gilt wood in which a quartzite sarcophagus was located. This sarcophagus in turn contained three nested coffins in the shape of a mummy. The mummy itself was covered by this mask – a masterpiece of Egyptian goldsmithery.

A likeness of the deceased is only hinted at, by the prominent lips for example. The face is surrounded by royal attributes: the folded headscarf, a vulture and a cobra above the forehead: the two heraldic emblems of Upper and Lower Egypt, and a ceremonial beard on his chin, which was part of the uniform required for public appearances. This one is made of glass and gold. The eyebrows and lid lines are also made of blue glass. The eyes themselves are made of obsidian and quartz.

Mummies were prepared for "millions of years", as "bodies for eternity". Face masks were made with no reference to anything coincidental or the body's condition at the time of death. Tutankhamun's face was not just idealized, but also embedded in colours and shapes designed to make the beholder forget the earthly, living-natural world. The colours: blue was associated with everything heavenly, gold was considered the "flesh of the gods" and symbolized eternity. The shape: the face was fitted into a pattern of horizontals and verticals. The vertical central axis begins above the forehead with the heraldic animals, runs across the nose bridge down to the ceremonial beard, where it is widened by the headscarf edges. The headscarf surrounds his face with strict horizontal lines. The rounded broad neck collar catches the vertical and the line system at the bottom.

The fact that this face mask and the many other treasures from Tutankhamun's tomb have once again seen the light of day is the result of coincidence and perseverance. Two Englishmen were involved in this feat. One was the wealthy Earl of Carnarvon, the other was the penniless Howard Carter. Carter had come to Egypt as part of an excavation team to copy inscriptions and paintings. Years later Lord Carnarvon hired him to continue excavations. The earl had led the wanton life of the rich until he had a serious accident and his doctors recommended he spend some time in a warm climate. Thus he went to Egypt. He did not want to sit around aimlessly so he organized himself an excavation licence for Thebes' West Bank. Carter became his excavation expert. Between 1907 and 1917 they searched without great success. They then turned their attention to the Valley of the Kings and finally on 4th November 1922 Carter found the entrance of a closed tomb. He waited until Lord Carnarvon had arrived from England. On 25th November 1922 they opened the entrance for the first time – it was one of the great days in the history of Egyptology. The treasures they found can now be admired in the Egyptian Museum in Cairo.

***Gold Mask of Tutankhamun**, c. 1323 BCE*
Gold, semi-precious stones, glass,
height 54 cm (21¼ in.),
width 39.3 cm (15½ in.),
weight 11 kg (24 lb)
Cairo, Egyptian Museum

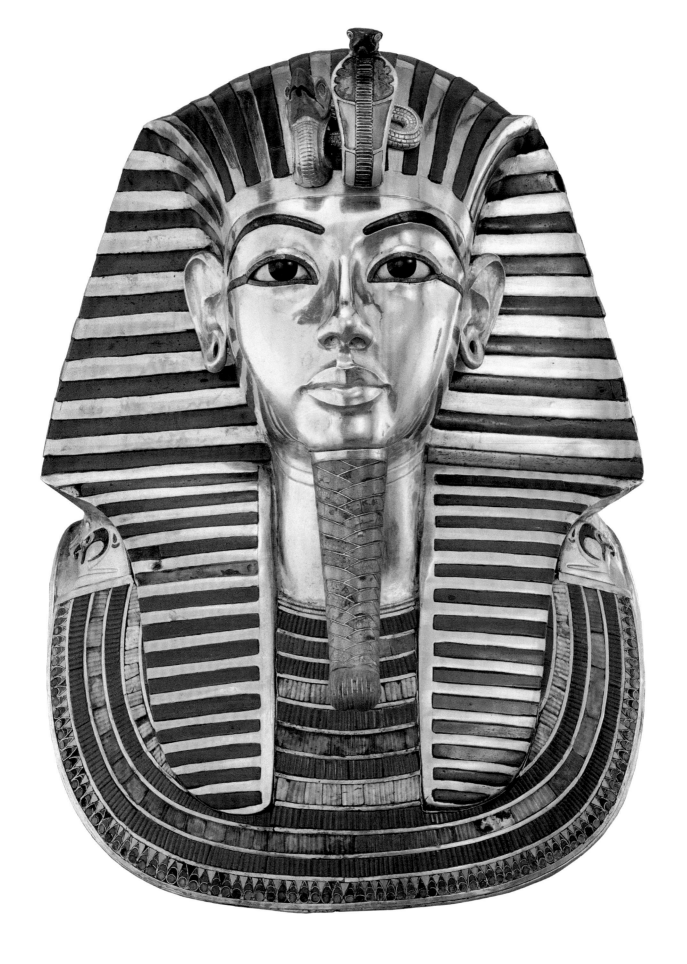

New Kingdom, 18th dynasty
Necklace of Tutankhamun, c. 1323 BCE

Necklace with a Scarab and Two Baboons, New Kingdom, 18th dynasty, c. 1336–1327 BCE
Gold and precious stones
Cairo, Egyptian Museum, from the tomb of Tutankhamun, Thebes, Valley of the Kings

One of the items of jewellery found in the tomb of the young king was this necklace. To us it is aesthetically pleasing, but for the Egyptians it meant very much more: it was a collection of signs and symbols with a mythic aura. Even the rectangular "bar" at the bottom end is more than just a visual finish. Together with the colour blue and the barque it became a symbol for the river Nile. The Nile was and is Egypt's lifeline. Only through its water is existence in the more than 1,000-kilometre-long river oasis possible. The gods determined the height of the annual inundation, it depended on them whether there would be a good harvest or a famine.

The Nile was more than a lifeline, it was also the main transport route. Larger transports and longer journeys were always done by boat, even after the Hyksos had introduced horses and chariots to Egypt in the 17th and 16th centuries BCE. The smaller boats for fishing and hunting consisted of bundles of papyrus bound together. The larger boats were built of wood, which usually came from Lebanon. Bow and stern of both types rose upwards, even if not in the shape of a round hook as on Tutankhamun's necklace.

Since the people travelled on the water, their gods did too. Early in the morning they entered their barque in the east, glided across the sky with the sun to the west, journeyed into the underworld, where they travelled on the river Nun back into the east. Accordingly priests placed the statues of their gods on barges and rowed them to their destination along the Nile during large processions. In 1954 archaeologists found pits next to the pyramid of Khufu (Cheops) containing all the pieces needed to assemble five complete barques. They put one of them together. It is now on display in its own museum: the barge is over 43 metres long, almost 6 metres wide, has two cabins, and its twelve oars are up to 8.5 metres long. Ships of such imposing size were designed for the pharaoh so that he could accompany the solar barque on its journey across the sky and through the underworld.

The most prominent passenger on the necklace's barque is a dung beetle. It is not an animal we hold in particular regard, but in Egypt it was highly venerated. Thus zoologists called it "Scarabaeus sacer" (sacred scarab). The Egyptians believed the scarab embodied the beginning of life, the original creation, the creation of all living things. They thought these beetles created themselves without parents or any other help, after which they emerged from balls of dung. Biologically speaking, the parents roll up these balls of dung to protect their eggs and larvae. The scarabs embodied more than just original creation, they also embodied one of the original gods. Over the course of the centuries he became merged with Atum, who in turn blended with the sun god Aten. This way the ball of dung became a symbol of the sun. Every morning the scarab pushed the sun or the solar barque across the horizon. The sun is represented as a glistening round disc on this necklace. The Egyptians used the beetle as a charm and a seal. Tourists travelling to Egypt today like to buy scarabs by the dozen as souvenirs and small presents.

The scarab on the barque is flanked by two narrow bands. They each consist of three symbols possessing magic powers: the Djed pillar at the top symbolizing stability, the ankh, the symbol for "life" in the centre, and at the bottom the hieroglyph representing lung and windpipe, symbolizing perfection. The scarabs and the solar disc are protected by Egyptian cobras. Each cobra is raising its head and has flared up its hood. Their eyes are spitting fire. They were considered to be a dangerous symbol of the power of their king.

Necklace of Tutankhamun, c. 1323 BCE
Gold, lapis lazuli, carnelian, feldspar, turquoise, length 50 cm (19¾ in.)
Cairo, Egyptian Museum

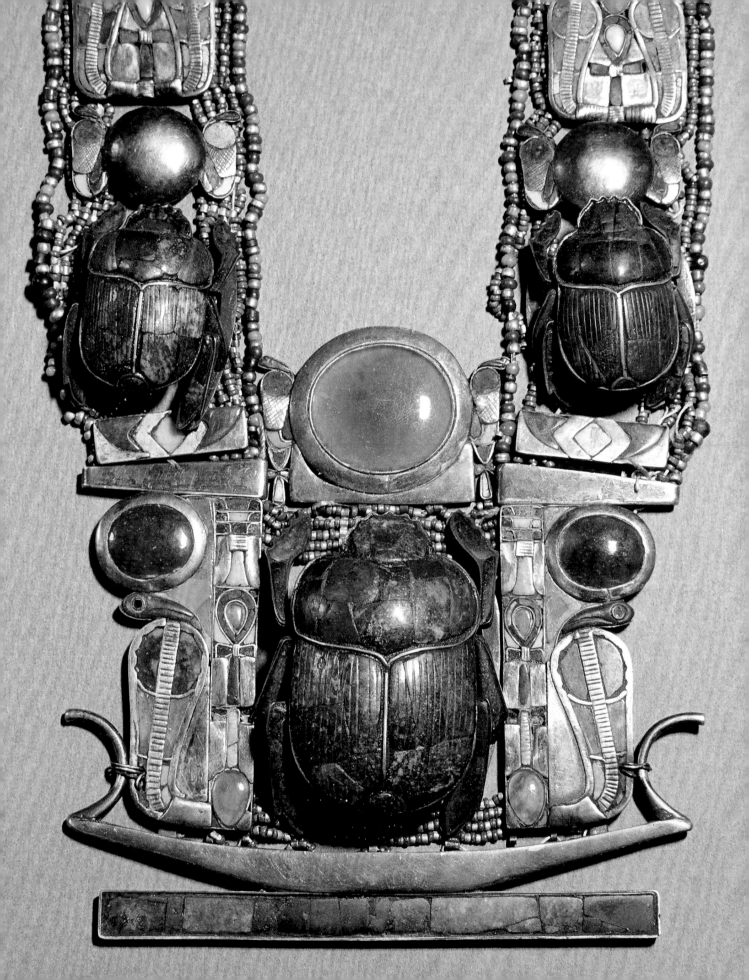

New Kingdom, 19th dynasty
Dancing Girl, c. 1300 BCE

"Very young, almost naked girls, 'of perfect body with long curls and firm breasts', entertained the guests at the banquet."

— GRAVE OF THE SCRIBE NAKHT, THEBES (TT 52), 18TH DYNASTY

A girl somersaulting backwards, painted by an unknown artist on an ostracon. The world comes from the Greek meaning "shell" or "potsherd". Egyptologists use it to describe clay shards and limestone fragments usually found in rubbish pits. These irregularly formed writing and painting materials were used for bills, inventories, prices, news and small literary texts. Artistic designs and or amateurish, hastily sketched scenes from everyday life were also found on them – such as a naked woman with unkempt hair, blowing the fire in the oven (ill. p. 16), or a stonemason hitting a chisel with a wooden hammer. Ostraca were excavated from a well shaft near the workers' village of Deir el-Medina that document the craftsmen's work in the royal tombs. They have told us that the workers worked in two four-hour shifts or that a worker was absent because his brother was being embalmed. These notes, sketches and bills written on scrap material give us a look at the world behind the elegant "front" of the highly stylized Egyptian art. Unlike the pictures and reliefs in the temples and graves they were not made for eternity, but for quick use.

The dancer performing the back somersault was not new in 1300 BCE. She was one of the motifs of Egyptian high art, albeit either not used a lot or else not many specimens have survived. The artist was using the limestone shard to practice and test his skills. He made the head of curls more flowing and the body more attractive – at least more voluptuous and beautiful than on a relief in the nearby mortuary temple of Queen Hatshepsut in Deir el-Bahri that was made around 250 years earlier. The graceful body on the ostracon displays its youthful suppleness. The figure is full-breasted. Her barely covered genitals are pushed forwards by her pose and her hair is seductively swaying below her. She is a borderline case in the representation of erotic scenes – at least for high art. The Egyptians were discreet in this area. Although temple walls do display the erect penis of Min, the god of fertility, human sexuality remains invisible. It was only hinted at in symbolic form. The Egyptians were more open in their literature. Many love songs have survived that sing about more than just pain and longing. One famous fairy tale talks about King Sneferu in a boat being rowed by twenty scantily clad girls "with beautiful limbs, deep breasts, braided hair, whose bodies have not been stretched in childbirth… Then his majesty's heart was happy at seeing the way that they rowed."

The acrobatically trained dancers also showed their abilities during religious celebrations, albeit more often when these were also popular festivals. One such was the annual journey of the goddess Hathor from her temple in Dendera to her husband, the god Horus, in Edfu. The statue's trip along the Nile was accompanied both on land and on water by a cheerful mass of musicians, acrobats, and of course dancers. Once a year Hathor also invited people to her temple for a "day of inebriety". Nowadays it is difficult to determine in what proportions worship, alcohol, sex, music and dance were mixed in such events.

Dancing Girl, c. 1300 BCE
Painting on limestone,
10.5 x 16.8 cm (4¼ x 6½ in.)
Turin, Museo Egizio, found in Thebes

New Kingdom, 19th dynasty
Anubis Watches over the Mummy, c. 1250 BCE

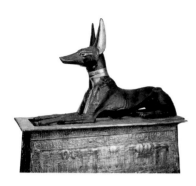

Wooden Statue of Anubis, New Kingdom, 18th dynasty, c. 1323 BCE
Painted black, decorated with gold and precious stones, height 118 cm (46½ in.)
Cairo, Egyptian Museum, from the tomb of Tutankhamun, Thebes, Valley of the King

A mummy, its face covered with a mask made of stuccoed linen, is lying on a bier with lions' heads and paws. "As light as a blown-out egg and as hard as a statue", this mummy – the end result of a seventy-day process – had to ensure the deceased's survival for "millions of years". After the rites at the deathbed the mummy was placed in a coffin. Relatives would then pull it on a sledge in a procession to its grave.

The figure protectively bending over the mummy is Anubis, the god of the dead. He is shown with a human body and a canine head (it is not clear whether it is the head of a dog or a jackal). He guarded the rock tombs in the guise of an animal. Probably in the hope of taming it, the Egyptians had chosen precisely that animal to protect their necropolises that roamed their cemeteries at night and threatened to dig up the dead. Anubis acted as the master of the embalming hall where the mummy was prepared. It was located close to the banks of the river Nile far away from residential areas, because water was needed to clean the deceased. It resembled an airy tent. The pattern on the wall behind the lion bier could be part of a carpet or a canopy spanned between two pillars. The final rites were completed by a priest who wore an Anubis mask during his embalming work, either for ceremonial purposes or out of considerations of hygiene.

As the result of thousands of years of development, the technique of mummification was at its peak at the time this representation was painted on the grave wall. The tomb belonged to Sennedjem, who lived in a craftsmen's village in the proximity of Thebes. He and his colleagues – master builders, carpenters, stonemasons, sculptors, contour draughtsmen and painters – all worked on the other side of the mountains on the pharaonic graves in the Valley of the Kings. In their free time they took care of their own tomb. Sennedjem's colleagues surely helped to build and furnish his "house of eternity". Although it does not have the size or magnificence of the royal tombs, it does have a naïve charm and it shows what ordinary Egyptians considered important.

The most important thing to them was the conservation of the intact body after death, because this is what their survival in the afterlife depended on. The Egyptians neither wrote down the embalming and mummification techniques they used, nor how they constructed the pyramids, but the Greek traveller Herodotus (484–431 BCE) wrote about it in detail: first the body was emptied and the brain thrown away, but the heart, where the Egyptians believed the personality to be located, was placed back in the body. The viscera were cleaned, put into canopic jars, and placed into the tomb. The body was filled with myrrh, closed up again, and dried for seventy days in natron. In order to preserve the body's shape the mummy was then wrapped in strips of linen and impregnated with an antibacterial, antifungal mixture made of anointing oil and resin.

Numerous religious rituals accompanied this procedure, the priest uttered magic formulas and gave the deceased charms to protect him in the realm of the dead, a dark, humid, and dangerous place. Anubis himself assisted the deceased at the judgement where the heart of the deceased was weighed. After he had successfully passed this test the deceased was considered "justified" and "transfigured". For that reason – acting with pre-emptive magic – the mummy mask on the coffin was given a forward-curving, plaited "divine beard" as a sign that the deceased was allowed to enter the idyllic reed-bed – Egyptian paradise.

Anubis Watches over the Mummy,
c. 1250 BCE
Wall painting, tempera on clay
Deir el-Medina, tomb of Sennedjem
(TT 1)

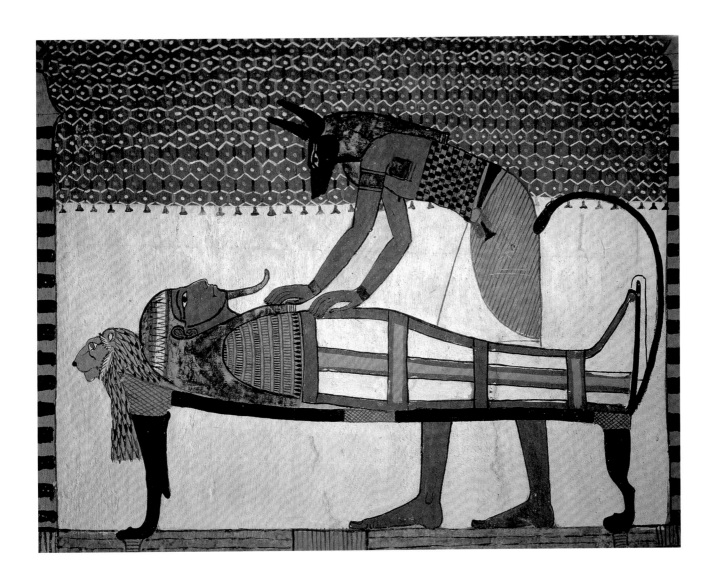

New Kingdom, 19th dynasty
The Judgement of the Dead, c. 1250 BCE

The English Egyptologist Sir E. A. Wallis Budge bought a scroll of papyrus from a grave robber in Luxor in 1888. It was 23.75 metres long and 42 centimetres high. He reported that when he unrolled it, the colours of the more than 3,000-year-old papyrus had still been quite fresh, but it darkened as soon as it came into contact with the air. The scroll was called the "papyrus of Any" after its original owner. It was cut into 37 sheets. Today it belongs to the British Museum.

The Egyptologist Richard Lepsius from Berlin was the first to call these scrolls "Books of the Dead". They were found in many graves between the legs of the mummy, also wrapped in the linen strips that held the body together. They were a kind of guide through the underworld. These breviaries contained around 200 utterances and colourful vignettes. The books of the dead were designed to familiarize the deceased with the underworld and gave him magic formulas that permitted him to avoid dangers and pass tests. Forerunners of these magic formulas had been chiselled into the pyramid walls. For a long time they were reserved for pharaohs. The more recent utterances were written down on scrolls of papyrus from 1550 BCE until Roman times and could thus also be obtained by Egyptians who were members of the upper class. The cost of such a book of the dead corresponded to around half a year's income for a craftsman. A large part of the papyri were ready-made so that only the buyer's name would have to be added.

The book of the dead belonging to the scribe Any from Thebes belonged to a more exclusive and artistic category than the ready-made papyri. It is possible that this high administrative official even wrote parts of the text himself. The scene shown here depicts him accompanied by his wife in suppliant stance to attend his judgement by several gods. This is the weighing of Any's heart. It will be weighed against a feather, the symbol of Ma'at, the goddess of justice and the highest moral authority of Egyptian society. Any's heart has to weigh the same as the feather if he is to pass the test successfully.

A person's earthly conduct was measured by the ideal of cosmic justice. Only few would be a match for such a test. Everyone feared the "second death". The magic formulas of the book of the dead were the only thing that could help. One such formula is the "negative confession": "I have not been unjust to another human being, I have not abused an animal" and – this was of particular importance in Egypt – "I did not hold back the flood waters in their season". If a deceased person made the correct magical utterances he was able to effect a favourable result for himself.

The weighing process is checked by the jackal-headed god Anubis, the "master of the necropolises" and protector of the dead. He is kneeling under the scales and is making sure with a plumb-bob that they are in balance. The ibis-headed god Thoth, god of the scribes and of magic, is standing next to him. He will write down the result of the judgement. This made it official and prevented Ammit, the "devourer of the dead" lurking behind Thoth, a monster part crocodile, part big cat and part hippopotamus, from devouring Any. He can hope to leave the dark depths of the underworld again soon and see the light of the sun. For that reason the Egyptians also called their guide for the underworld the *Book of Going Forth by Day*.

The Judgement of the Dead, c. 1250 BCE
Scene from the Papyrus of Any,
overall length 23.75 m (78 ft.),
height 42 cm (16½ in.)
London, The British Museum

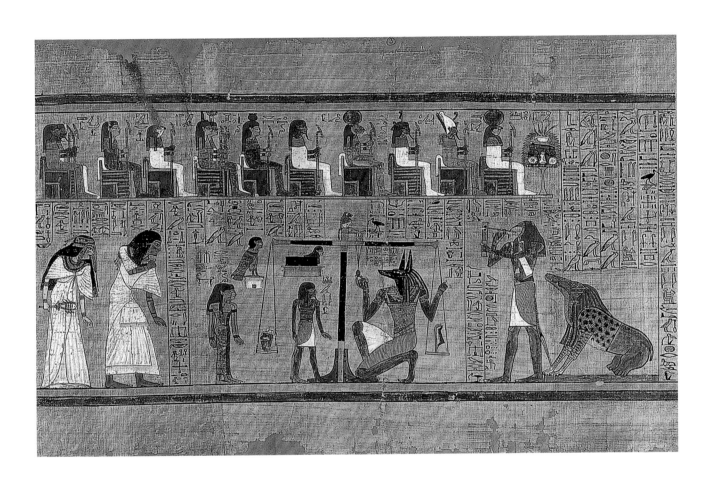

New Kingdom, 19th dynasty
Reedbeds, c. 1250 BCE

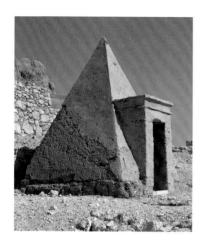

Restored Entrance to the Tomb of Sennedjem, New Kingdom, 19th dynasty
Deir el-Medina

This sequence of images recalls of a modern comic strip: it is arranged on several levels and depicts the fields of Aaru, the Egyptian paradise. It covers the eastern wall of a small rock tomb in the village of Deir el-Medina. This tomb belonged to the artisan Sennedjem who worked with his colleagues on the pharaonic tombs in the nearby Valley of the Kings. Sennedjem decorated the narrow space of his tomb with many well-preserved vignettes painted on a simple clay background over several layers of plaster. They date back to the book of the dead circulating during the Ramesside period and show the tomb's owner and his relatives in great detail and fresh colours performing various actions.

One of the things portrayed is the afterlife, something the Egyptians started carefully preparing for while they were alive. If after the mummification process and burial rituals the deceased passed the test to be allowed to enter the afterlife and convinced the judges that he had not committed any serious wrongs in his life, he was considered "justified". This gave him access to the fields of Aaru. The alternative was to be devoured by Ammit, the "devourer of the dead".

The Egyptians living in the Nile valley naturally imagined their paradise to be a green, sunny garden, a happy island, always surrounded by water bringing fertility to the land. The picture is framed by a heavenly Nile, traditionally depicted as a blue-green band with wave patterns. The lower two levels show red flowers, while date palms and sycamore-fig trees bear fruit to refresh the hungry.

The two levels above show the tomb's owner and his wife working the land. They are ploughing the earth with a pair of oxen, sowing and harvesting flax, cutting wheat and collecting the ears. These are all activities the couple would hardly have done in their actual lives. Every deceased person could expect to fill the same position in the afterlife they had had in this life, but all of them – even kings – were required to help in food production. However, there this work can be done in festive clothing and the ears grow so high they can be harvested without the need to bend down. Thus, depictions of agricultural labour were part of the pool of scenes used in private tombs since the Old Kingdom.

Magic could also help Sennedjem remove himself from the unfamiliar agricultural work. To this end Sennedjem was given many miniature figurines to take to the grave with him. These Shabti, or "answerers", were equipped with hoes and sacks and could stand in for the deceased revived by magic utterances when his name was called out for work.

In the first scene on the far right the upright mummy of Sennedjem is being revived by the "opening of the mouth" ritual. A young man is paddling on a papyrus boat towards the new arrivals. This man is their son who predeceased his parents. After entering the afterlife Sennedjem and his wife are allowed to proceed to the island of the blessed. Both are kneeling before the sun god Ra, the god of the dead Osiris, Ptah, and two minor gods. Divine Ra, solar disc on his head, towers above the paradisiac setting in his heavenly barque. The inscription describes how he, Osiris, is worshipped by the baboon on the right when he rises and by the baboon on the left when he sets. In one book of the dead it says:

"The monkeys of the sun worship you, / announce you at the gateway of the horizon, / they dance before you, they sing before you. / You take your seat in the day barque."

Reedbeds, c. 1250 BCE
Wall painting, tempera on clay
Deir el-Medina, tomb of Sennedjem
(TT 1)

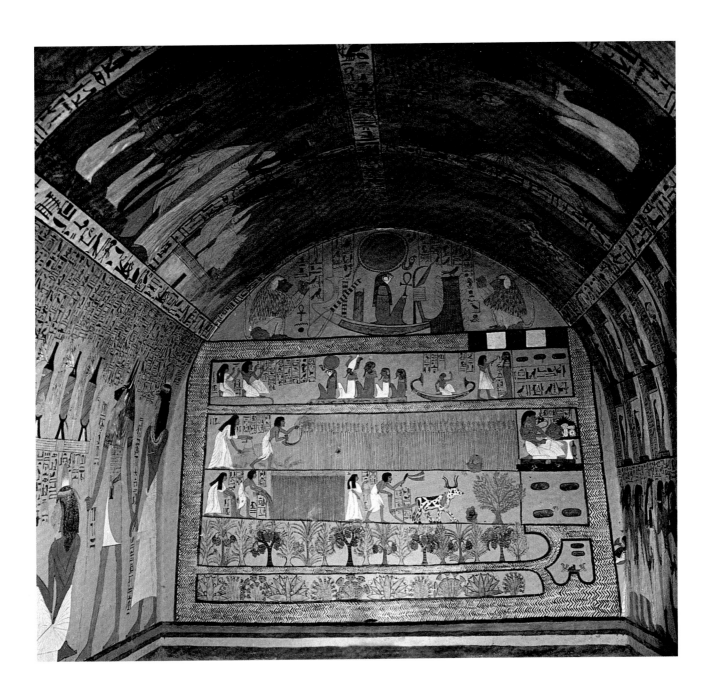

Third Intermediate Period, 22nd dynasty
The Eye of Horus, 945–924 BCE

Portrait of a King, New Kingdom, 20th dynasty, c. 1140 BCE
Limestone shard, 42 cm (16½ in.)
Cairo, Egyptian Museum, from the tomb of Ramesses VI, Thebes, Valley of the Kings

It is very rare that Egyptians depicted a head from the front on their temple and grave walls. If people or gods were painted or depicted in a relief, they were shown in profile. This side-view was not complete however. There were two items the beholder saw from the front: the shoulders and the eye. Both parts of the body must have been particularly important to the Egyptians. Maybe the width of men's shoulders demonstrated their strength. When representing kings there was also the added opportunity to show the regalia – the crook and flail crossed in front of his chest – clearly from the front. Similarly with the eye: the eye needs to be shown from the front to portray its size or also the colour of the iris and the shape of the surrounding lids.

In comparison with the other sense organs, the eyes had a high, if not the highest rank. This can be gathered from the many myths in which gods and divine animals are equated with eyes. The uraeus rearing at the front of the royal crowns was considered to be the fire-spitting eye of the sun god. The goddess Hathor was also thought to be the Eye of Ra and when the people rebelled against Ra the gods advised him to send Hathor, because there was "no eye that could destroy them better for him". The "evil eye" seems to have played a role in popular belief and one of the pyramid texts mentions two evil eyes that were sealing a door. The first people, so it was said, had been created from tears that had dripped out of the eyes of the creator god. Eyes were ascribed magic powers capable of destroying, but also of healing. The idea of the healing-eye – the Eye of Horus – probably originated from a popular mythical story. The subject is an argument between gods. The fighting parties were Horus and Set. They were fighting about which one of them was going to succeed Osiris, who had been murdered by Set: Horus, as Osiris's son, had the legitimate right to succeed him, whereas Set, being both older and stronger, was more capable of defending the old order. It is a divine conflict we can very well imagine mirrored an earthly pattern. Such a conflict must have occasionally occurred when it came to determining who was to be pharaoh. After many duels, Set brutally ripped out one of Horus's eyes. The god Thoth found the eye and put it back together again. Horus gave it to his father Osiris who thereby reawakened to new life. The healed eye gives life-force.

In the Egyptians' mythical world view such stories about their gods were always current, they visibly repeated themselves in the celestial bodies for example: the waning and waxing of the moon corresponded to destruction and healing, and the sun was also an eye of Horus: "When he opens his eyes, he fills the universe with light, and when he closes them, darkness is created." The mortal Egyptians thought of the eye of Horus as a charm. It was and still is the most popular of all the magical, protective and healing tools in Egypt.

King Shoshenq I's bracelet was found in Tanis, his city of residence in the eastern part of the Nile delta. The bracelet consists of a gold base with thin, flat bars forming receptacles in which the semi-precious stones and white faience were placed. The line at the outer corner of the eye corresponded to the way Egyptians made themselves up. Men also used make-up and wore jewellery. The mummy of Shoshenq II wore a total of seven bracelets on both arms, two of them depicting the eye of Horus.

The Eye of Horus, 945–924 BCE
Bracelet belonging to King Shoshenq I, found in Tanis, cloisonné work with lapis lazuli, diameter 6.5 cm (2½ in.)
Cairo, Egyptian Museum

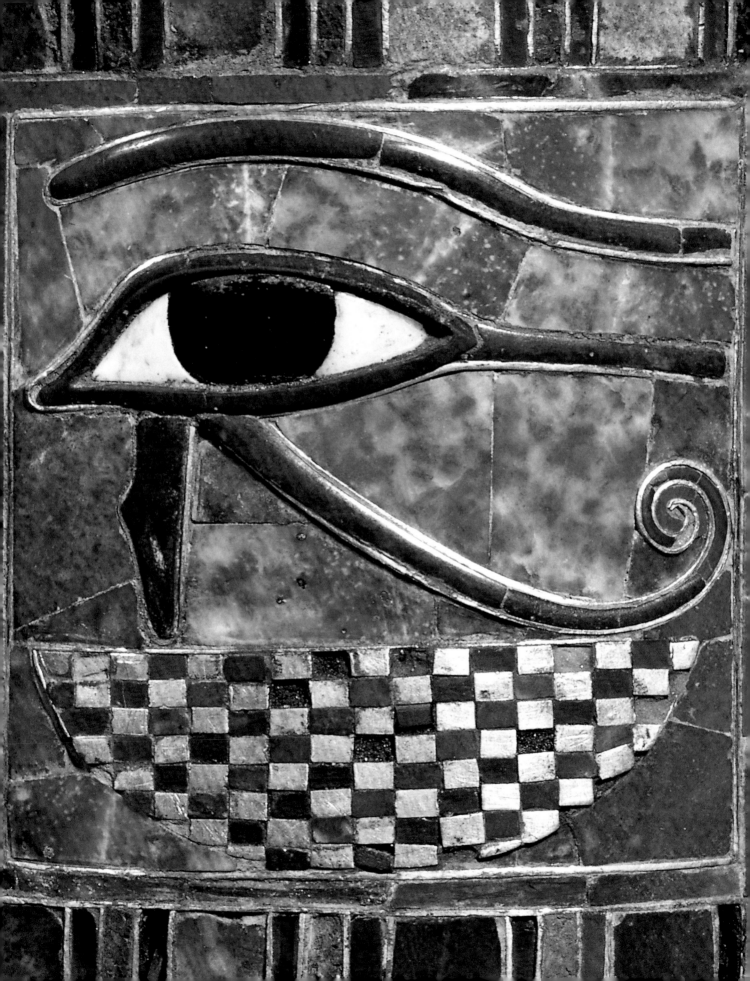

Ptolemaic Period
The Horus Falcon in the Temple of Edfu, 237–57 BCE

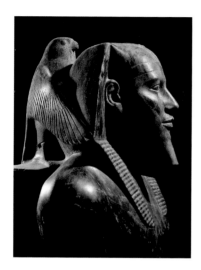

Pharaoh Khafra with the Horus Falcon,
Old Kingdom, 4th dynasty,
c. 2572–2546 BCE
Diorite statue
Cairo, Egyptian Museum, from Giza

The Temple of Edfu, located a good 100 kilometres south of Luxor, is amongst the most beautiful buildings on either side of the Nile. It is a late work, hardly damaged, and once again realizes the ideal of an Egyptian temple complex. Two massive towers – only Karnak has higher ones – make up the entrance. Continuing on a straight axis there is an open court, two column halls, then smaller rooms, all the way to the innermost sanctum, to the chapel containing the statue of the resident god that was only accessible to its priests. The god living in this temple was Horus. His cult image is missing. Presumably it was made of gold and gemstones, broken apart by robbers, and melted down. Pictures and texts on the walls show that the god was treated as if he were a living person. He was woken, cleaned, and anointed by the priests in the mornings, given new clothes, and food and drink. These ceremonies were repeated twice a day. Once a year he was visited by his wife Hathor from Dendera. At the beginning of the year the statue of the god was carried up on to the temple roof to be strengthened by the sun. Throughout the twelve months of the year a rich festival programme was offered to him (and the populace).

He is not just the master of the house, he also guards it. In the form of a falcon he is standing next to the gate that leads from the uncovered courtyard, where the populace was allowed to gather on festival days, to the entrance of the first column hall. Grand and dignified he stands there; originally there were two statues, one on each side of the gate, but one of the sculptures has collapsed.

Like most of the gods, he too did not remain unchanged over the centuries and millennia. Initially the Egyptians probably saw Horus in the sky, as a falcon whose wings reached from horizon to horizon and whose eyes shone like the sun and the moon. As the god of the sky he became Ra's companion and travelled with the highest of all the gods in the royal barque on his daily journey across the sky from east to west and back again on the river of the underworld at night. He was one of the keepers of the cosmic world order, but in one mythical story he was also the son of Isis who had avenged the death of his father Osiris and was thus worshipped as a child with magical powers, powers that were supposed to protect against snakes and scorpions in the actual world. Horus lost an eye in a fight, which the god Thoth put back together again. Horus gave it to his murdered father, who thereupon reawakened to life: this was also an act that continued to have an effect on the Egyptians as a model for how they made their sacrifices.

In their theology Horus was not just considered to be the god of the sky, but also the god of the kings. Horus was embodied in the ruling pharaoh. Whenever a new pharaoh ascended the throne the name of the god was added to his other names. An impressive statue of Pharaoh Khafra has survived from the 4th dynasty on which the artist shows the Horus falcon with open wings sitting on the back of the neck of the king. In the Ptolemaic period, the Egyptians no longer believed in the divine character of their pharaohs. The temple god himself was now considered to be the true pharaoh, the real ruler of Egypt. Edfu still contains reliefs with traditional motifs, but in representative places, where the kings of previous dynasties had themselves depicted as statues, they had disappeared. Horus stands guard alone at the entrance to the first column hall. He himself in the guise of a falcon wears the pschent – the double crown, which was the traditional symbol of power.

***The Horus Falcon in the
Temple of Edfu***, 237–57 BCE
Granite sculpture, height with
base c. 3 m (9.8 ft)

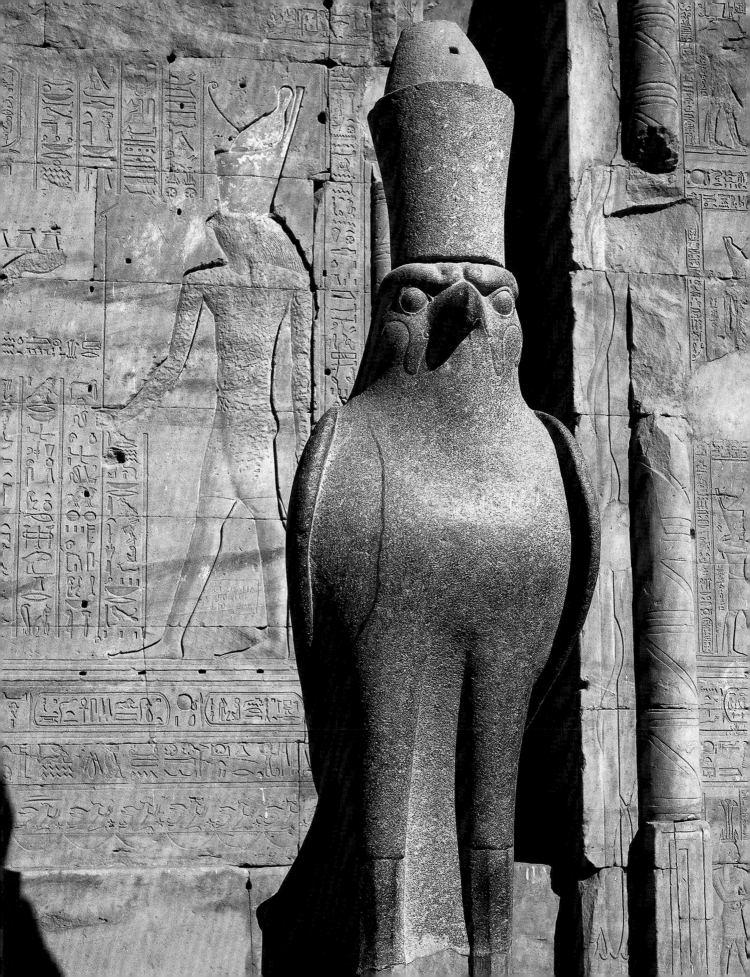

Ptolemaic Period
Two Goddesses Crowning the Pharaoh, between 181 and 145 BCE

The Temple of Edfu, c. 237–57 BCE

The relief depicts one of the oldest scenes of Egyptian royal ideology: the unification of the two lands through the act of coronation. On the left is Nekhbet, the goddess of Upper Egypt and representative of the southern part of the country. Opposite her stands Uto, the goddess of Lower Egypt that reached from Memphis to the Mediterranean. Nekhbet is wearing the hedjet, the white crown of Upper Egypt, while Uto is wearing the deshret, the red crown of Lower Egypt. They are united to form a double crown on the head of the pharaoh.

For 3,000 years every pharaoh completed the unification ritual when he ascended the throne. In images this was represented by the presence of the two goddesses, or also by binding together papyrus and lotus, the symbolic plants of the two parts of the kingdom. The great significance of this constantly reaffirmed unification can be traced back to Egypt's geography: a wide, densely populated river delta and a 1,000-kilometre-long land often only populated close to each side of the river bank. The country was divided into nomes that made themselves independent during times of weak rule and also fought each other. Behind this unification ritual was not just the memory of the kingdom's creation, but also the fear of the chaos, of the outbreak of uncontrollable forces that constantly threatened their precious order. The unknown artist who designed the three figures wanted to visually represent the harmony in which the two parts of the country found each other or were supposed to find each other through symmetry. The two goddesses are the same size, have their feet placed forward the same amount, and are not just wearing the same vulture cap, but also wigs of the same length. Both bodies are youthfully slim and their dresses come together below the bust. The hands with the overly long fingers touching the crown in unison have their thumbs on the wrong side. Here the artist was more concerned with the overall aesthetic appearance than correct human anatomy.

The relief was created towards the end of a period of political decline that had drawn out for almost 1,000 years. In 946 BCE a Libyan prince took over the reign in the north and later Nubians entered the south, followed by Assyrians. Between 664 and 525 BCE the kingdom was ruled by another Egyptian dynasty, but then the Persians came twice and when Alexander the Great defeated them, he also gained control over Egypt. His Greek general Ptolemy and his descendants ruled until the death of Cleopatra VII in 30 BCE, in other words shortly before the start of the Common Era.

Ptolemy VI ruled between 181 and 145 BCE. It was during his reign that this royal relief representing harmony and security was created, an ideal far removed from the actual conditions, which were marked by civil war. It can still be seen in Edfu, one of several temples built during the time of the Ptolemies and amongst the most beautiful in the country because of their architecture and decoration (and their excellent state of preservation). Like the previous foreign rulers, the Ptolemies also took over the pharaoh cult and supported the building activities: either because they admired Egyptian culture or to pacify the population. They and particularly the priests, we may surmise, compensated for the loss of real power and national dignity with the construction of new buildings and the maintenance of traditional ceremonies. There may well have also been Egyptians who did not like to see the beautiful relief glorifying the ruling, foreign pharaoh.

Two Goddesses Crowning the Pharaoh, between 181 and 145 BCE
Stone relief on the temple wall of Edfu

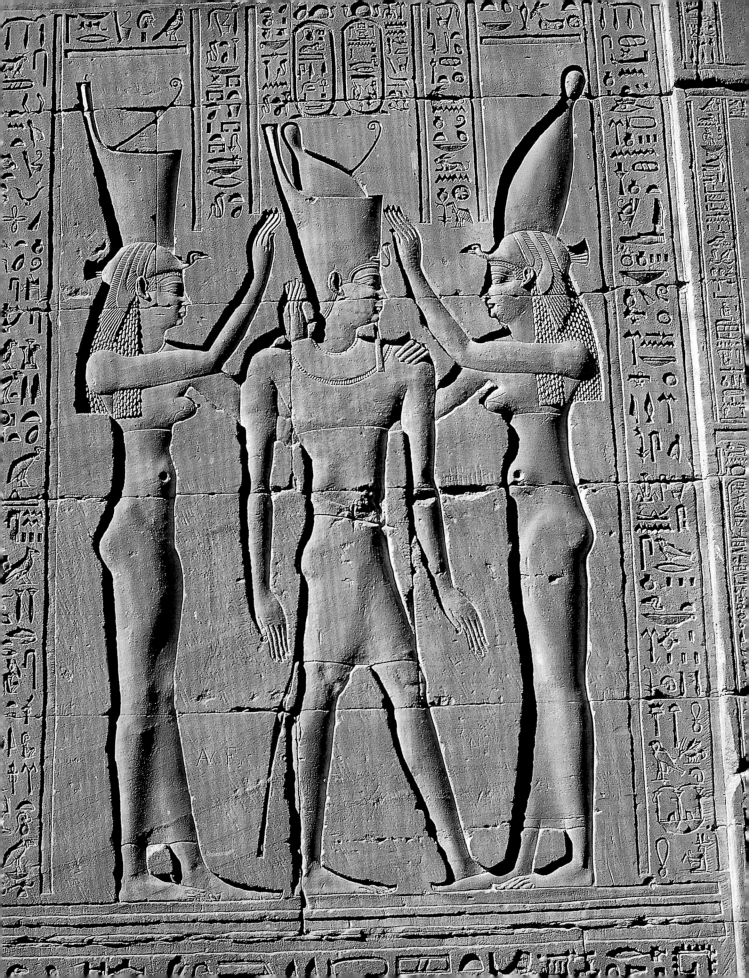

Roman Period
Mummy Portrait of a Woman, c. 24 CE

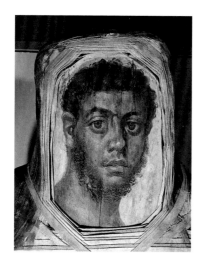

Mummy Portrait of a Young Man,
c. 30 BCE–313 CE
Linen, wax painting on wood,
length 175.5 cm (69 in.)
Berlin, Ägyptisches Museum

The portrait shows "Aline, also known as Tonos, daughter of Herod" who died at the age of 35 in "the year ten". This can be gathered from an inscription on the gravestone. The Egyptians started their calendar count anew with each new ruler, however the year ten here probably does not refer to any Egyptian pharaoh but to the Roman emperor Tiberius. If that is the case, Aline died in 24 CE. The curls on her forehead correspond to the fashion of that time.

Egypt was a Roman province, Italian and Greek merchants did their business from Alexandria. Macedonian veterans lived in Al Fayyum. They all brought their own customs and their artistic habits with them. One example of this is Aline's shroud. It was found in Al Fayyum together with many other "mummy faces" of the same kind. In earlier centuries only rulers and the highest officials had their mummy faces covered with a decorated mask. The death mask of Tutankhamun is a particularly rich specimen. The masks found in Al Fayyum were not found in the graves of the highest ruling elite and they were not made of expensive materials either. They were painted on wood or on cloth. Under Aline's cloth portrait were pieces of canvas, which balanced any unevenness of the face. The cloth must have lain over the head almost like a flat picture.

It is a portrait in Greco-Roman style. It allows us to name some of the special characteristics of Egyptian painting in comparison. The Egyptians accepted the surface and did not attempt to create the illusion of depth. They also showed their faces two-dimensionally. Aline's face on the other hand is moulded. The tip of her nose seems to be further forward than the hair on her head or than her ears or even than the diffuse background. Highlights on the nose and forehead as well as shadows under the chin create the illusion the face has a slightly moving surface, as if it could change like it was still breathing, as if it were still alive. There is nothing like it in traditional Egyptian art.

Egyptian art had no interest in such surface appeal. It does not show what the eye can see, but what the seen means. A person shown to be tall has a higher social standing than a person shown to be short. If a pharaoh was grasping the scalps of several captives in one hand and swinging a club over their heads with his other hand, it does not represent a real situation, but a royal duty: defeating enemies. The facial skin is always taught, single-coloured, and unmoved. It reveals nothing about the age, nothing about its condition, nothing about the moment in which it was painted. Everything that could remind beholders of time and transience was filtered out in Egyptian painting.

Most of the ancient Egyptian stylistic idiosyncrasies can be explained by the location where they were used. Private buildings were made of wood and clay bricks and have not survived. We know little about what could be seen on their walls. What has survived are grave complexes and temples built of stone. There a person's social or religious significance was more important than his appearance, and everything that was supposed to last for eternity was more important than what was transient. It was a sacred art that created its own style, a style that corresponded more to the ideas about the afterlife and eternity. It was not a style that wanted to create portraits to capture a person's earthly appearance.

Mummy Portrait of a Woman, c. 24 CE
Tempera painting on canvas,
height 42 cm (16½ in.),
width 32.5 cm (12¾ in.)
Berlin, Ägyptisches Museum

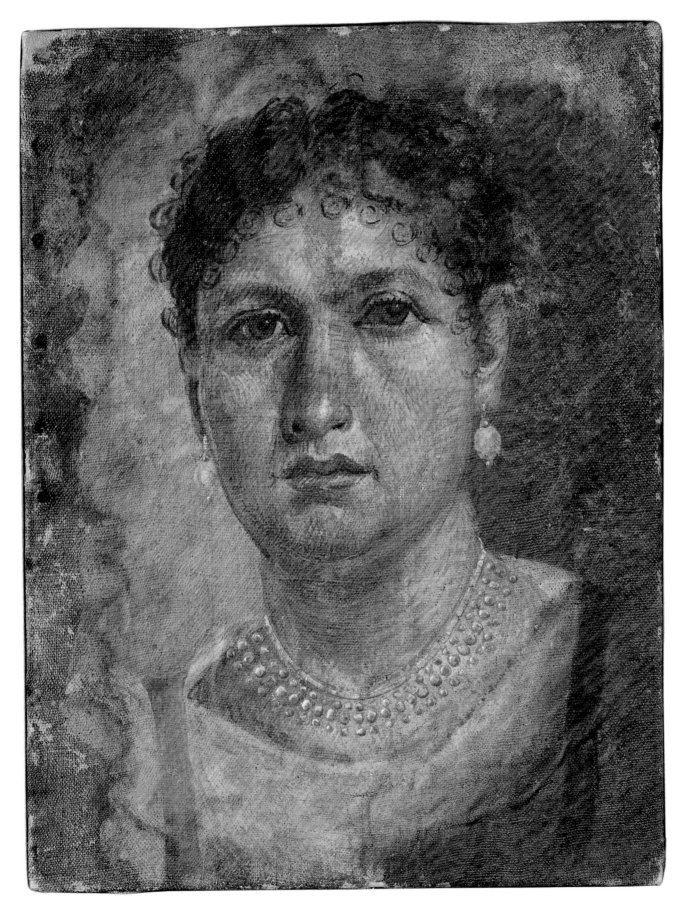

Alexandria

Damietta

Cairo

Giza

Saqqara

Beni Hassan

Tell el-Amarna

Abydos

Qena

Dendera

Karnak

Luxor/Thebes

Esna

El-Kab

Edfu

Kom Ombo

Elephantine

Aswan

Philae

Kalabsha

Gerf Hussein

Abu Simbel

Chronology of Ancient Egypt

(after Beckerath)

Predynastic Egypt 7000–3000 BCE
Nomadic tribes settle on the banks of the river Nile

Early Dynastic Period 3032–2707 BCE
1st and 2nd dynasties
Upper Egypt (Aswan to Cairo) and Lower Egypt (Nile delta)
become unified
Invention of writing

Old Kingdom 2707–2170 BCE
3rd to 8th dynasties
Memphis becomes the capital
Kings are worshipped as gods
Djoser's Step Pyramid, Sneferu's Bent Pyramid, the Pyramid
of Cheops, Khafre's Pyramid with the Great Sphinx of Giza

First Intermediate Period around 2170–c. 2020 BCE
9th and 10th dynasties
Anarchy, collapse of the kingdom, the state as divine
order is questioned

Middle Kingdom 2119–1793 BCE
11th and 12th dynasties
Reunification of the kingdom, expansion to Nubia,
Thebes becomes the capital
Growing interest in Osiris and the underworld
Cube statues

Second Intermediate Period 1794–1550 BCE
13th to 17th dynasties
The Hyksos rule Egypt

New Kingdom 1550–1069 BCE
18th to 20th dynasties
After the Hyksos had been expelled, campaigns of conquest
were fought all the way to Syria and the Euphrates
Egypt becomes a "world power", Thebes is the capital again
Temples at Luxor (Thebes) and Karnak, rock tombs in the
Valley of the Kings
Queen Hatshepsut, Temple at Deir el-Bahri
Akhenaten replaces the plurality of gods with a single one,
Aten, visible as the sun. He also changes the artistic canon
Tutankhamun's tomb of 1323 BCE remains unplundered, its
opening in 1923 is a sensation
Ramesses II surpasses predecessors through building huge
monuments: Great Hypostyle Hall in Karnak, the Great
Temple at Abu Simbel, Ramesseum

Third Intermediate Period 1070–714 BCE
21th to 24th dynasties
The kingdom collapses, rulers change quickly

Late Period before 746–335 BCE
25th to 31st dynasties
Libyan, Nubian, and several Persian rulers

Ptolemaic Period 332–30 BCE
Alexander the Great subdues Egypt along with Persia
The Greek dynasty of the Ptolemies rules from 304 BCE and
ends with the death of Queen Cleopatra VII
Egypt becomes a Roman province
Temples dating from the Ptolemaic period: Dendera, Edfu,
Kom Ombo, and Philae, amongst others

Photo Credits

The publisher wish to thank the museums, private collections, archives, galleries and photographers who granted permission to reproduce works and gave support in the making of the book. In addition to the collections and museums named in the picture captions, we wish to credit the following:

© Albright-Knox Art Gallery, Buffalo: 71
© akg-images / Erich Lessing: 81
© Axiom, London: 9
© Boltin Picture Library / Bridgeman Images: 75
© bpk / Ägyptisches Museum und Papyrussammlung, SMB / Jürgen Liepe: 10, 58; bpk / Ägyptisches Museum und Papyrussammlung, SMB / Georg Niedermeister: 92; bpk / Antikensammlung, SMB / Johannes Laurentius: 25; bpk / Margarete Büsing: 72; bpk / Kunstbibliothek, SMB, Preußischer Kulturbesitz: 7; bpk / Alfredo dagli Orti: 88
© The Bridgeman Art Library, Berlin: 4, 6, 15, 17 bottom
© The British Museum, London: 83
© Corbis / Roger Wood: 19, 39
© Griffith Institue, University of Oxford, colourised by Dynamichrome: 27
© Jürgen Liepe, Berlin: 20 top, 29, 32/33, 43, 47, 48, 49, 69, 80, 86
© The Metropolitan Museum of Art, New York: 12/13, 14 top
© Photo RMN, Paris – B. Hatala: 37
© Photo Scala, Florence: 17 top; Scala, Florence / HIP: 11; Scala, Florence / HIP: 28, 53, 90; Scala / The Metropolitan Museum of Art / Art Resource: 45; Scala, Florence / Photo Werner Forman Archive: 61
© Skira, Milan: 55
© Henri Stierlin, Geneva: front cover, 84, 87, 91
© Frank Teichmann, Stuttgart: 41
© Photo Eberhard Thiem, Lotus-Film, Kaufbeuren: back cover, 1, 2, 16, 20 bottom, 23, 24, 42, 46, 50, 57, 59, 63, 65, 66, 67, 71, 73, 74, 79
© Werner Forman Archive: 40, 85, 89; Werner Forman Archive / Museu Calouste Gulbenkian, Lisbon: 44; Werner Forman Archive / Egyptian Museum, Cairo: 21, 30, 31, 34, 51, 68, 76, 77; Werner Forman Archive / Musée du Louvre, Paris: 35
© Dietrich Wildung, Berlin: 14 bottom

The authors

Rose-Marie Hagen was born in Switzerland and studied history, Romance languages, and literature in Lausanne. After further studies in Paris and Florence, she lectured at the American University in Washington, D.C.

Rainer Hagen was born in Hamburg and graduated in literature and theater studies in Munich. He later worked for radio and TV, most recently as chief editor of a German public broadcasting service. Together they have collaborated on several TASCHEN titles, including *Masterpieces in Detail*, *Pieter Bruegel*, and *Francisco de Goya*.

FRONT COVER
The Eye of Horus, 945-924 BCE
Detail of a bracelet belonging to King Shoshenq I
Cloisonné work with lapis lazuli, diameter 6.5 cm (2½ in.)
Cairo, Egyptian Museum

PAGE 1
Scarab Pendant Belonging to Tutankhamun
Gold and precious stones, 9 x 10.5 cm (3½ x 4¼ in.)
Cairo, Egyptian Museum, from the tomb of Tutankhamun, Thebes, Valley of the Kings

PAGE 2 AND BACK COVER
Queen Ankhesenamun in Front of Her Husband Tutankhamun,
New Kingdom, 18th dynasty, c. 1323 BCE
Inlay work on Tutankhamun's throne, gold, silver, and semi-precious stones
Cairo, Egyptian Museum

PAGE 4
Rahotep and Nofret, Old Kingdom, 4th dynasty, c. 2620 BCE
Limestone, painted, height 121/122 cm (47¾/48 in.)
Cairo, Egyptian Museum

Imprint

EACH AND EVERY TASCHEN BOOK PLANTS A SEED!
TASCHEN is a carbon neutral publisher. Each year, we offset our annual carbon emissions with carbon credits at the Instituto Terra, a reforestation program in Minas Gerais, Brazil, founded by Lélia and Sebastião Salgado. To find out more about this ecological partnership, please check: www.taschen.com/zerocarbon
Inspiration: unlimited. Carbon footprint: zero.

To stay informed about TASCHEN and our upcoming titles, please subscribe to our free magazine at www.taschen.com/magazine, follow us on Instagram and Facebook, or e-mail your questions to contact@taschen.com.

© 2022 TASCHEN GmbH
Hohenzollernring 53, D–50672 Köln
www.taschen.com

Original edition:
© 2007 TASCHEN GmbH

Scientific advisor: Martin von Falck, Hamburg
Translation: Michael Scuffil, Leverkusen

Printed in Slovakia
ISBN 978–3–8365–4917–2